IMAGES
of America

GERMAN
CHICAGO
THE DANUBE SWABIANS
AND THE AMERICAN AID SOCIETIES

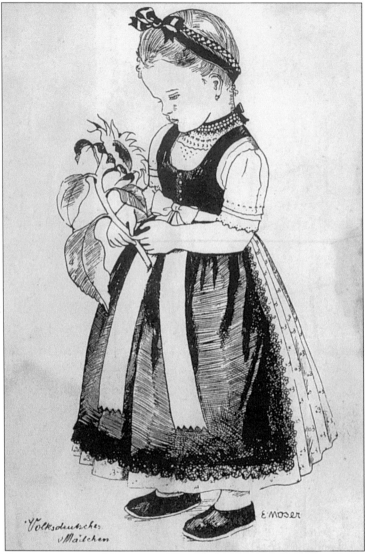

E. Moser. Volksdeutsches Mädchen. The American Aid Society sold this postcard in Chicago for 10¢, *c.* December 1948. A fragment from the poem "Auswanderer" (Immigrant), by the poet Heinrich Erk, from the Banat, was written on the back of the postcard.

Die Brücken brachen. Unser Auge sah
Die alte Heimat nebelig verdämmern
Und immer noch war keine neue da.

The bridges broke.
Our eyes saw our old homeland vanish in the fog,
and still there was no new one.

Cover: **New York City, 1965.** Although I focus on Chicago, it was these Danube Swabian-American girls in the Steuben Day parade that grace this cover. (Photograph courtesy of Eva Mayer, College Point, New York.)

IMAGES
of America

GERMAN
CHICAGO
THE DANUBE SWABIANS
AND THE AMERICAN AID SOCIETIES

Raymond Lohne

ARCADIA

Published by Arcadia Publishing,
an imprint of Tempus Publishing, Inc.
2 Cumberland Street
Charleston, SC 29401

Printed in Great Britain.

Library of Congress Catalog Card Number applied for.

For all general information contact Arcadia Publishing at:
Telephone 843-853-2070
Fax 843-853-0044
E-Mail arcadia@charleston.net

For customer service and orders:
Toll-Free 1-888-313-BOOK

Visit us on the internet at http://www.arcadiaimages.com

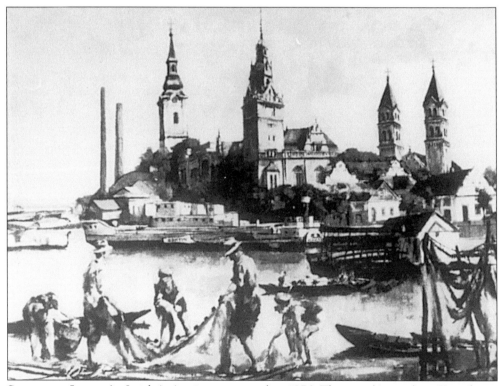

SEBASTION LEICHT'S. Leicht's *Apatin* was painted in 1976. This city (Apatin), in Yugoslavia, was a Danube Swabian center.

CONTENTS

Introduction

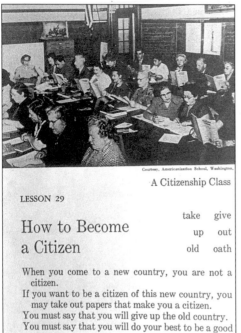

A Citizenship Class

LESSON 29

How to Become a Citizen

take give

up out

old oath

When you come to a new country, you are not a citizen.

If you want to be a citizen of this new country, you may take out papers that make you a citizen.

You must say that you will give up the old country.

You must say that you will do your best to be a good citizen.

You must take an oath that says these things.

This collection of images was cast into a framework so that a somewhat complicated subject could be introduced in some reasonable fashion. I chose to use a "Home Study Course" booklet from the *U.S. Federal Textbook on Citizenship*, 1946 edition, for my "frames" at the beginning of each chapter. I dedicate this effort to the spirit of Jan van Eyck, a Flemish master who flourished around 1430 and whose painting were called "miracles of accuracy," which might seem the best that a photographic history could hope for.

In the *Petrine Revolution in Russian Imagery*, James Cracraft notes that Jan van Eyck was credited with being, "the first painter to design his own frames as integral parts of his pictures, with the object of heightening their separate reality.

The dedication to a painter by a historian is appropriate because I need to introduce here a pair of Danube Swabian master painters named Susanna Tschurtz and Sebastian Leicht, flourishing, you might say, in 1999, whose paintings I can not exactly term "miracles of accuracy," but which I could define as miracles of spirit, by which I mean the human spirit in one of its powerful manifestations as the spirit of survival, if only in memory. These are the German people living in Chicago and other major American cities whom the American Aid Societies for the Needy and Displaced Persons of Central and Southeastern Europe tried to save after World War II.

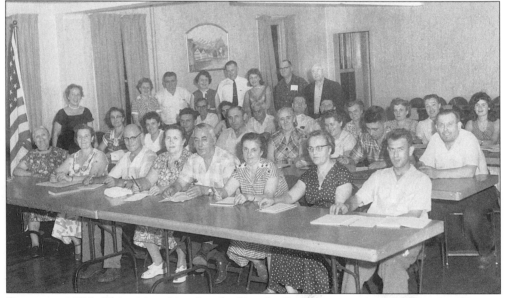

CHICAGO, 1956. This citizenship class for Danube Swabians was sponsored by the Chicago Board of Education. (Photograph courtesy of the American Aid Society.)

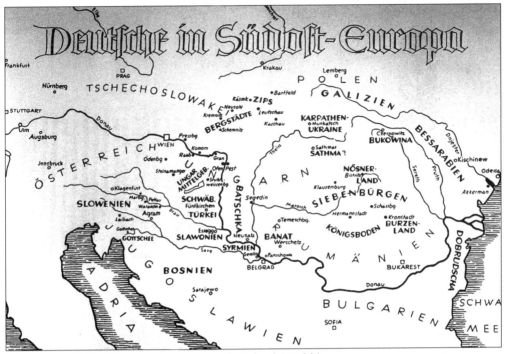

KERNEI, C. 1961. (Photograph courtesy of Michael Stöckl.)

Who are these Donauschwaben, and how did they come into existence as a distinct group of Germans? Leo Schelbert, in an essay in *Perspectives in American History* entitled "On Becoming an Emigrant," said the following:

> Throughout history one observes in almost all human communities a phenomenon that may be described as exchange migration. Emerging and ever changing specializations in economic pursuits create fluctuating needs which are often filled either temporarily or permanently by people from the outside. Besides this form of migration a historically less frequent, but in its impact more significant, type can be observed which may be termed expansionist migration-the expansion of a nation's territorial or economic domain into (mostly transoceanic) outliers.

The migration of Germans into the middle Danube regions from 1686 until 1829 is of this expansionist type. Simply put, the Austrian Empire won back territory from the Ottoman Empire and thereby created conditions in the kingdom of Hungary similar to those in America and Russia. Estimates for the Catholic Germans alone, who were offered special incentives to emigrate, run to 150,000 in approximately 1,000 villages over the 143 year period. Homesteads, money, tax exemptions, seed, lumber, and other devices were used to attract these Germans. It was a migration that would transform both the land and the people who went there. For further study, Sebastian Leicht's *Weg der Donauschwaben: Graphischer Zyklus* and Susanna Tschurtz's *Illustrations On The Theme Annihilation Camp Rudolfsgnad* are two fine artistic portraits of this people that will reward the reader with the kind of visual and spiritual impact only art can have. In these two masters, the Donauschwaben are painted in accomplishment as well as tragedy.

If I introduce a pair of artists, I should also have a few historians to introduce from among the Donauschwaben, and I do, starting with Michael Stockl, author of the book *The Kerneir Families Gartner and Wurtz And Their American Branches.* He was born in 1920, the very year this small village in the Batschka was to become Krnjaja, Serbian Yugoslavia. He spent his boyhood in Kleinstapar, a village near Kernei on the Kaiser Franzens Kanal, first dug by the Germans to drain swamp water out of the area that ended up connecting the Theiss to the Danube.

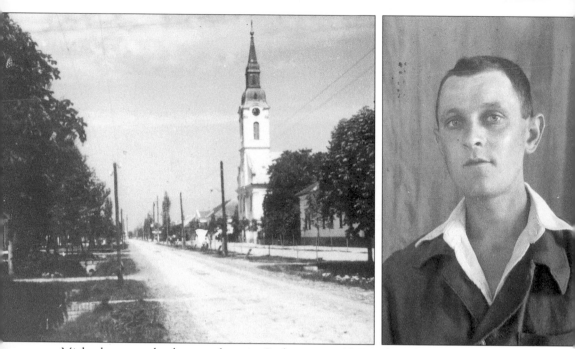

Michael was a theology student in Budapest, in 1944, when he was diagnosed with tuberculosis and had to go back home. Two days after Christmas, he and all the other able-bodied men and women of German origin were ordered into cattle cars at gunpoint. After a harrowing train journey, he arrived at the coal mine in Stalino, Russia, where he worked as a slave laborer from January 1945 until late 1948, when he was finally released. He immigrated to the United States under the provisions of the Refugee Relief Act of 1953. He has been a historian and genealogist of Kernei ever since.

Adam Ackermann is a historian and teacher whose book, *Kernei in der Batschka 1765-1945*, is introduced here. In his book, Michael Stockl noted the first mention he had found of Szent Kiraly, which became Kernjaja, in a Turkish tax collection book of the year 1590, when but 20 houses stood to pay the tax.

Another pair of historians I would like to introduce are Nikolaus Hess, who wrote the book *Heimatbuch der drei Schwestergemeinden, St. Hubert, Charleville, Soltur in Banat*, and Joseph Stein, who was born in 1937 in St. Hubert. A high school teacher for 30 years, he holds a Master's degree in history from Northeastern Illinois University and was my first teacher among the Donauschwaben. He is a survivor of the terrible events that took place at the village of Rudolfsgnad, north of Belgrade in 1944–45, where the Serbs took out their revenge on anyone German left behind when the war ended, events which the American public is largely unaware of. How is that possible? For answers, we must look first to our journalists, who report for us.

Robert St. John was born in Chicago, served in the U.S. Navy during World War I, and became a reporter on the *Chicago American* and the *Chicago Daily News* from 1922 through 1924. He and his brother even owned a couple of papers. Eventually he became the Associated Press night city editor in New York City between 1931 and 1933 and the Balkan correspondent for the years 1939 to 1941. It is because of his activities in this regard that he comes to my attention, for in 1947, he went on a long tour of Yugoslavia, an incredible and painful journey through cities and remote villages, recording stories of war into a book entitled *The Silent People Speak*, which was published by Doubleday in 1948. In his introduction he states the following:

> Now the test really begins. This is the Balkans. And its midwinter. They're short of fuel all over the country. Things will be grim in many ways. The Balkans aren't like New York or Chicago or San Francisco. This is the edge of the Orient, even if it doesn't look like it

on the map. Just existing here, the way Americans like to exist, is a job. A man hunting for the truth would have other problems.

I would have to agree with everything in this paragraph, especially the part about "the hunt for truth" in Yugoslavia, for it was in Belgrade, at the beginning of his journey, that Robert St. John and another reporter were accosted by "a little man," who asks for their help. It was an illuminating incident.

Then excitedly, the little man explained. He had been to the American Embassy. The American Embassy said that the first step was to get some American to sign a statement of financial responsibility, guaranteeing that the immigrant, if he got to

A m e r i c a ,

would not become a public charge. Peter did not reach immediately for his fountain pen. Instead he asked: Why do you wish to leave your own country?

That started it. For the next fifteen minutes the little man, in a voice loud enough to be heard out in Terazzia, told what he thought of the New Yugoslavia. And it wasn't much. He got so excited that half the time he was talking in Serbian and half the time in his broken English. He spoke a great deal about Osna. He talked of "The Terror". He said no man's life was safe. People were always getting arrested and then disappearing.

Months later, as he was leaving Belgrade at the end of his journey, St. John couldn't resist when he stated "... a last visit to the trafika in Terazzia that sells foreign publications. The unhappy little man who wanted to get to America was still there. "The Terror" hadn't gotten him yet."

Aldous Huxley once wrote that, "The greatest triumphs of propaganda have been accomplished, not by doing something, bur by refraining from doing. Great is truth, but still greater, from a practical point of view, is silence about truth."

Robert St. John gave his book an apt title, in my view, for *The Silent People Speak* does let many "little men and women" speak on the horrors of World War II in Yugoslavia, but something is missing, and it is an omission that lets the Catholic German civilians speak the loudest of all, by their absence, as it were; for what the AP reporter refused to believe from an old Serb in 1947, the former Austro-Hungarian Germans of his hometown in America knew in 1944, especially Nikolaus Desch and John Meiszner.

There were other death camps in the revenge business in the ancient kingdom of Serbia, and this time the criminals were not the Germans.

<div align="right">
R.A.L.

Chicago, 1999
</div>

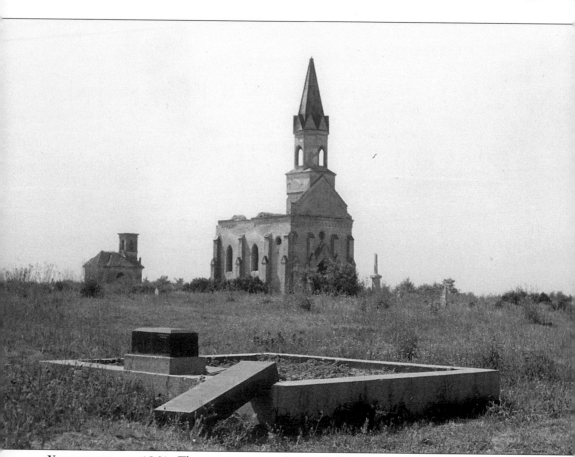

YUGOSLAVIA, C. 1961. These ruins are symbolic of all that remains of the former German presence in Yugoslavia.

One

RIGHTS AND DUTIES IN THE UNITED STATES

The truth about Yugoslavian ethnic cleansing is what created the American Aid Societies for the Needy and Displaced Persons of Central and Southeastern Europe in the first place. Word had come to Chicago in late 1944 from Dr. Kaspar Muth, a senator in the Romanian legislature, and the word was bad. In Chicago; the Bronx; St. Louis; Milwaukee; Detroit; Cincinnati; Buffalo; Philadelphia; Pittsburgh; Mansfield, New Jersey; and Elizabeth, New Jersey, a long-standing community slowly emerged behind Nick Pesch and John Meiszner in the cause of humanitarian relief for the German refugees. This is nothing new among America's Germans, as Melvin Holli proved when he brought the records of the German Aid Society, c. 1873–1896, to the Library of the University of Illinois at Chicago. People in America do "meet to talk about their needs," and this participation in the political process includes the Donauschwaben.

People Meet To Talk About Their Needs

LESSON 27

Rights and Duties in the United States

more think duties fight say about harm

What are your rights in the United States?
You have the right to go to the church that you like best.
You have the right to think as you want to think.
You can say what you think is right.
You have other rights that you will need to learn about some time.
Everyone has duties in the United States.

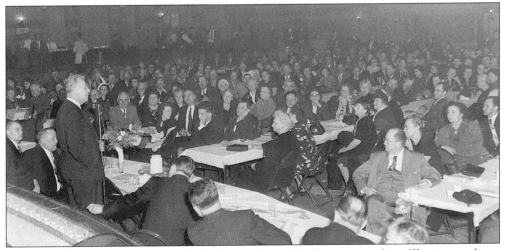

CHICAGO, 1950. Everett McKinley Dirksen, the newly-elect senator from Illinois, speaks to the Danube Swabians of Chicago at the Logan Square Masonic Temple on December 10, 1950. (Photograph courtesy of the American Aid Society.)

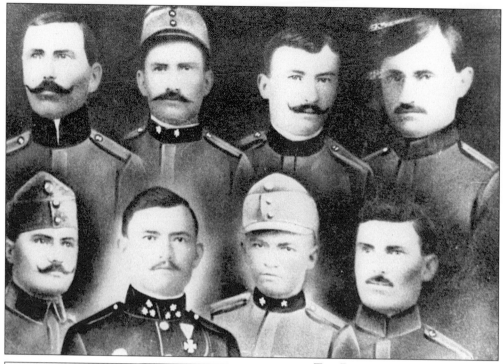

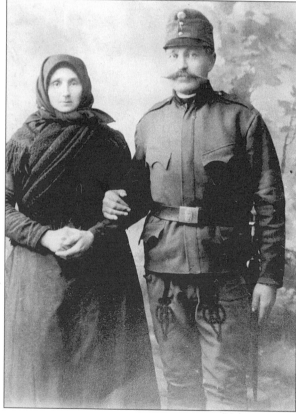

THE BRAUNSTEIN BROTHERS, GORJANI, 1914–18. One of the duties of citizenship is the requirement to serve in the military when called upon by the government. This photograph composition comes from the *Heimatbuch Tomaschanzi-Gorjani* by Josef Werni, Konrad Reiber, and Josef Eder. The uniforms would change when the boundaries of their nation changed after World War I.

JOSEF AND KATARINA GLASENHARDT, VISKOVCI, AUSTRIA-HUNGARY, C. 1916. Josef, a blacksmith by trade, is wearing the uniform of a cavalry officer. (Photograph courtesy of Katherine Glasenhardt.)

JOSEF MILLER. In the center of photograph, Josef Miller poses with friends in the uniform of the Serbian military, *c.* 1927. Hitler's invasion of Yugoslavia in 1941 forced the Donauschwaben into a terrible position, their only choice being between Hitler and Stalin. (Photograph courtesy of Katherine Glasenhardt.)

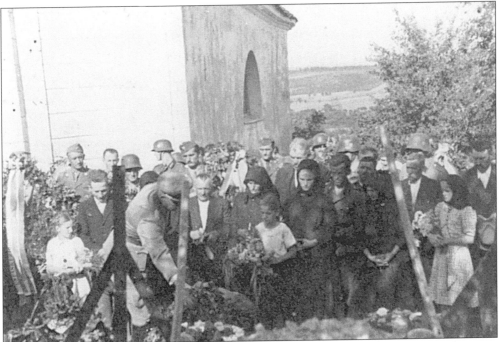

G. EDER AND K. MILLA. The two men being buried were killed during the fighting in Yugoslavia, *c.* 1943. (Photograph courtesy of *Heimatbuch Tomaschanzi-Gorjani.*)

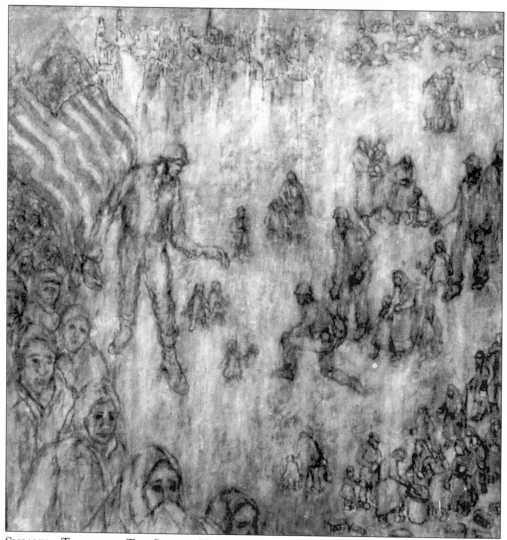

SUSANNA TSCHURTZ, *THE SAVIOR.* Her village, Morawitca, in the Romanian Banat, was the first to flee the advancing Red Army in August 1944. Susanna spent eight years in refugee camps before coming to the U.S. under the provisions of the Displaced Persons Act of 1948. A graduate of Northwestern University, her life and work is an unexplored subject, except among her own people. As we shall see, they recognize what they possess in this woman. (Photograph courtesy of Susanna Tschurtz.)

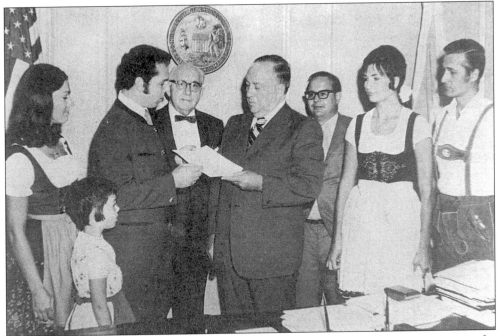

SUSANNA TSCHURTZ. On the right with her late husband, Robert, Susanna was part of a delegation from the German-Day Organization inviting Chicago Mayor Richard M. Daly to the 50th German Day celebration. (Photograph courtesy of the Society of the Danube Swabians of Chicago.)

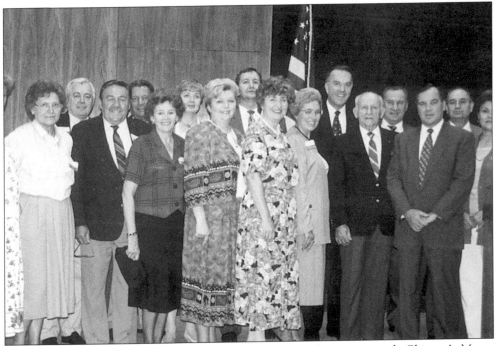

CHICAGO, 1994. Members of the Society of Danube Swabians pose with Chicago's Mayor Richard J. Daly in 1994. (Photograph courtesy of the Society of Danube Swabians of Chicago.)

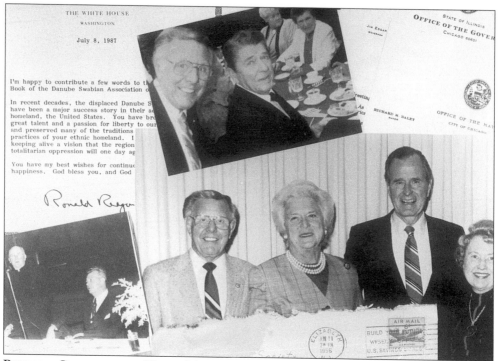

RICHARD GUNTHER AND HELEN MEISZNER. They are the last living adult witnesses to the creation of the American Aid Society. (Photograph collage by Raymond Lohne, 1997.)

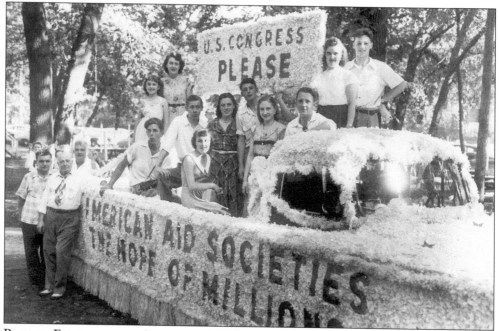

PARADE FLOAT OF THE AMERICAN AID SOCIETY, CHICAGO, C. 1950. Helen and Joyce Meiszner are seen standing in the back of the float. Math Gatsch, front, Helen's father, and Sam Baumann are standing beside it. (Photograph courtesy of the American Aid Society.)

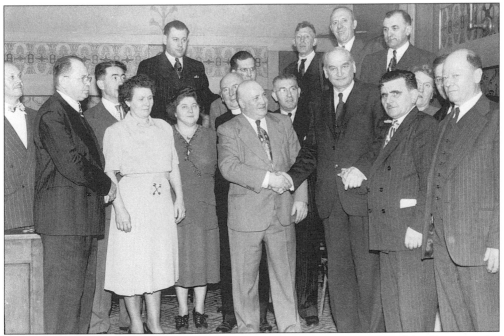

WILLIAM LANGER. Charles M. Barber's recent work on the "Maverick" of the Senate is the most interesting to date on this controversial American political figure from North Dakota. Here he is at the annual American Aid Society banquet in Chicago, December 12, 1948. (Photograph courtesy of the American Aid Society.)

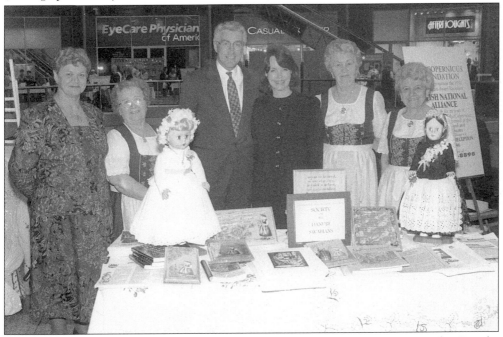

CHICAGO. Jim Edgar, governor of Illinois, and his wife, Brenda, stop to visit the Danube Swabian exhibit in the Thompson Center. (Photograph courtesy of the Society of the Danube Swabians of Chicago.)

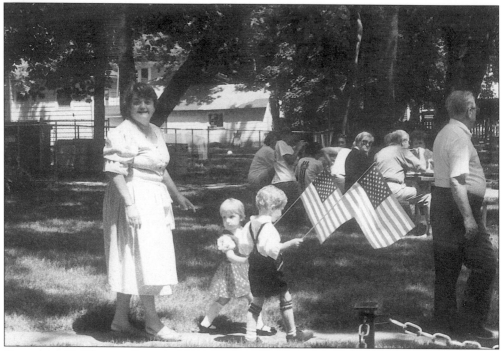

ELIZABETH B. WALTER, JULY 4, 1997. Her autobiography, *Barefoot In The Rubble*, won her the American Legion Auxiliary's "Woman of the Year" Award for 1998. (Photograph courtesy of Raymond Lohne.)

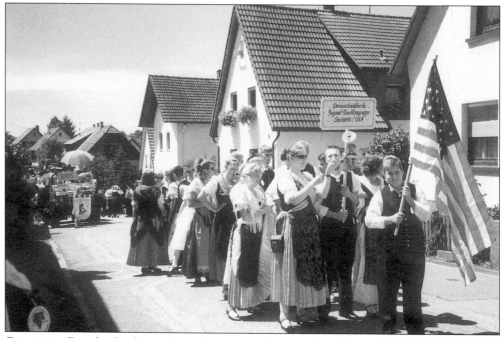

GERMANY. Danube Swabians from Cincinnati, Ohio, on a field trip in Germany, represent "communal reconnections," if we may call them that, of the Danube Swabian Diaspora. (Photograph courtesy of the Cincinnati Donauschwaben.)

ELIZABETH GEBAVI. While campaigning for the Illinois governorship in August 1998, George Ryan was given a special tour of the Heimatmuseum of the American Aid Society by Museum Curator Elisabeth Gebavi. This museum contains many rare and irreplaceable historical items, such as paintings, books, hand-carved mousetraps, beautiful dressed, and other things from the old country. As fine an example of Danube Swabian saddle-making as exists anywhere in the world also resides here. (Photograph courtesy of the American Aid Society.)

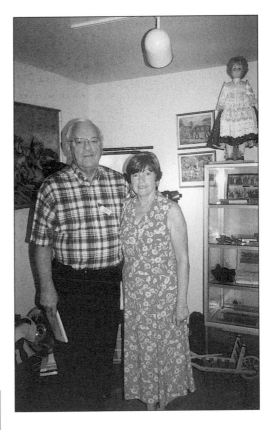

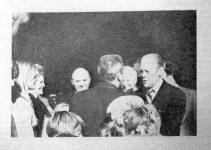

Gerald R. Ford, Präsident der Vereinigten Staaten von Amerika im Gespräch mit Herrn Matthias Aringer, Generalsekretär des Verbandes der Donauschwaben in den U.S.A. Herr Aringer überreichte dem Präsidenten die goldene Ehrennadel des Verbandes, wofür er tieferstehendes Schreiben aus dem Weissen Haus erhielt.

THE WHITE HOUSE
Washington

November 18, 1976

Dear Matt:

Your warm welcome during my recent visit to Milwaukee and the tapestry which you presented were deeply appreciated. It has been a tremendous honor to serve the people of our great country, and I will always remember the generous encouragement extended to me and my entire family by our fellow Americans. I thank you from my heart for your friendship and wish you the best for the future—for this Nation's future is closely linked to yours and that of other young people like you.

Sincerely,

Jerry Ford

Matt Aringer
6060 North 118th Street
Milwaukee, Wisconsin 53225

MILWAUKEE, 1976. If the American public in general seems oblivious to the Danube Swabian presence, the same may not be said of American politicians, now or in the recent past. In this photograph, Gerald R. Ford, President of the United States, receives *Die Goldene Ehrennadel des Verbandes*, the Golden Pin of Honor of the Association of Danube Swabians. (Photograph courtesy of the Milwaukee Donauschwaben.)

19

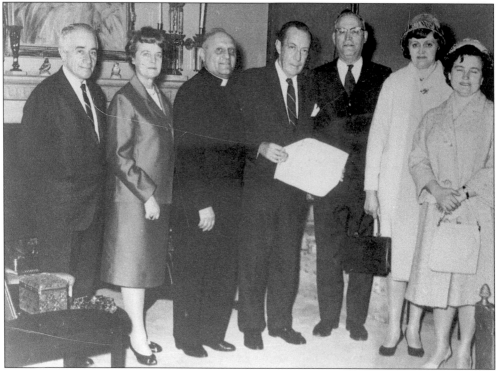

NEW YORK CITY, 1965. The founding committee of the German Romanian Society of New York presents a plaque and honorary membership to Mayor Robert Wagner. (Photograph courtesy of Eva Mayer, New York Donauschwaben.)

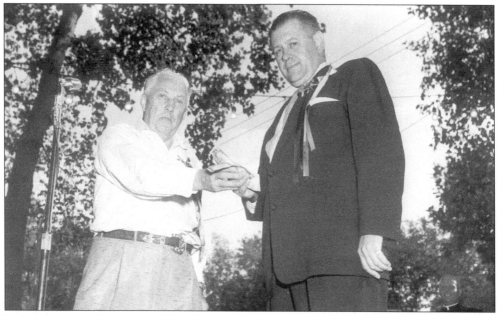

JOHN MEISZNER. In August 1956, Charles H. Weber, the Democratic boss of Chicago's 45th ward, offers the symbolic cash gift for Danube Swabian refugees in Europe. (Photograph courtesy of Helen Meiszner.)

Two

A FAMILY

I placed political participation first, to broaden the perspective, but lesson number one in the *Federal Textbook on Citizenship* concerned the family, and the Donauschwaben would have been surprised if this was not first.

U. S. Dept. of Agriculture

LESSON 1

A Fan

I have

A Family

a family h

I have a family.

We have a home.

JOHN, HELEN, AND JOYCE MEISZNER. These three can be seen with Congressman Timothy Sheehan, 11th District of Illinois, at the Logan Square Masonic Temple in Chicago, December 10, 1950. Meiszner's role in the Refugee Relief Act of 1953 and his relationship to Sheehan remains to be examined. John Meiszner was a "political" man in that he became a key player in attracting American politicians, but it should also be kept in mind that he, too, had a family trapped in Tito's Yugoslavia. (Photograph courtesy of Helen Meiszner.)

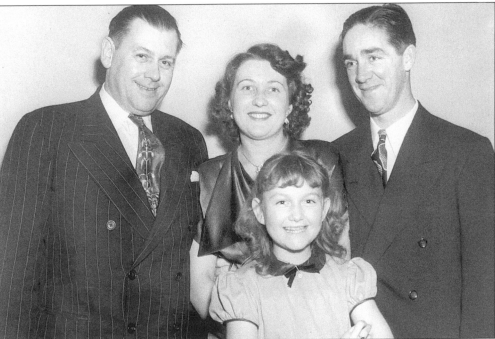

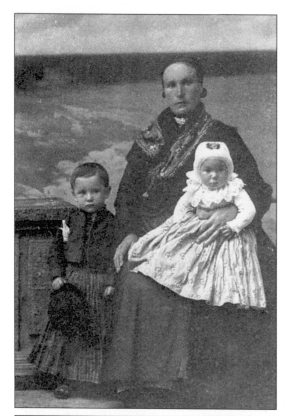

KERNEI, C. 1905. This photograph of a mother and her children came from Adam Ackermann's previously mentioned scholarly study *Kernei in der Batscka 1765–1945*. These *Heimatbucher*, homeland books, were generally done by a village teacher or priest, and were published privately. They represent important historical source materials, as their introduction here hopes to demonstrate.

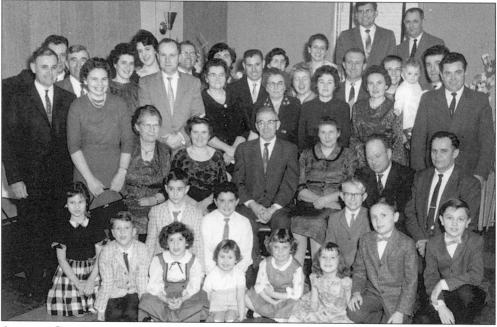

ANDREW GARTNER AND FAMILY, CHICAGO, 1974. This man's ancestors arrived in the village of Kernei in 1766, a story which is documented in *The Kerneir Families Gartner and Wurtz and Their American Branches* by Micheal Stöckl. (Photograph courtesy of Michael Stöckl.)

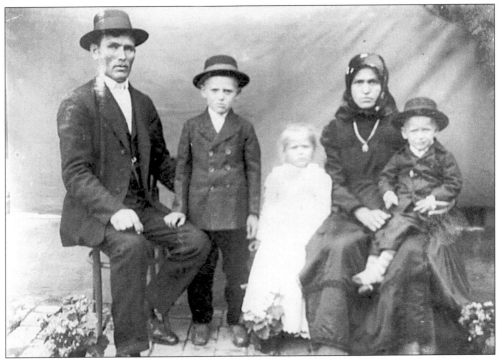

JOHANN GLASENHARDT AND FAMILY, GORJANI, YUGOSLAVIA, C. 1942. (Photograph courtesy of Katherine Glasenhardt.)

FAMILY OF NIKOLAUS PESCH. Dorothy and Elizabeth Pesch, with Susan (center) and little Megan, Nick's great granddaughter, can be seen on their first visit to the Nick Pesch Memorial on May 30, 1999. Hans Gebavi, president of the American Aid Society, accompanies them. (Photograph courtesy of Raymond Lohne.)

GORJANI, C. 1940. Gorjani sits in the courtyard of the Glasenhardt home on a Sunday afternoon. (Photograph courtesy of Katherine Glasenhardt.)

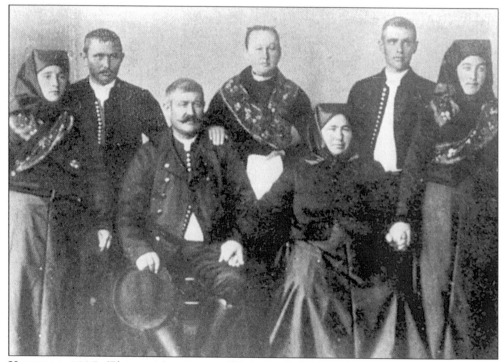

KERNEI, C. 1895. (Photograph courtesy of *Kernei in der Batschka.*)

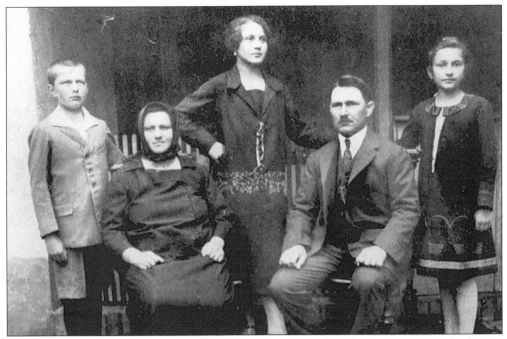

NIKOLAUS HESS. The family of Nikolaus Hess, historian and teacher, was photographed in St. Hubert, c. 1927. (Photograph from Hess's *Heimatbuch der drei Schwestergemeinden, St. Hubert, Charleville und Soltur im Banat 1770–1927.*)

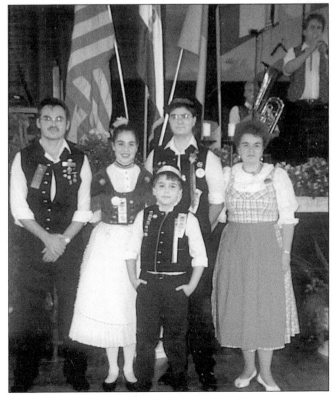

FRANK AND EDITH WEIL. The Weils can be seen with their two sons, Adam and Kevin, and their daughter, Amy. (Photograph courtesy of Kretschmann, Milwaukee Donauschwaben.)

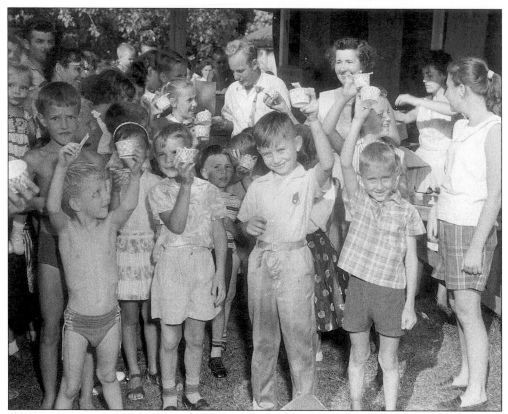

RICHARD GUNTHER. Gunther passes out ice cream on the American Aid Society grounds, *c.* 1956. (Photograph courtesy of the American Aid Society.)

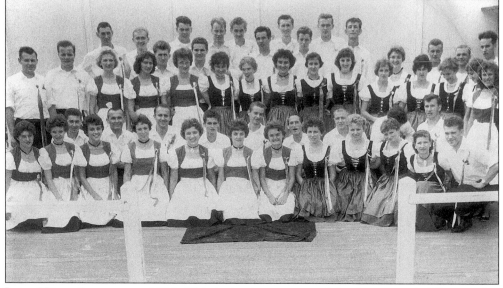

LAKE VILLA, ILLINOIS, C. 1956. This is the dance group of the American Aid Society. Joe Stein is in the second row, far left. Elsa Walter is kneeling, seventh from the left. (Photograph courtesy of the American Aid Society.)

Three
I WORK

In 1949, Nick Pesch finally went to Europe to make a "first-hand" report from the refugee camps for the American Aid Societies. As founder and leader, he was the logical choice to go. He shot a silent film of this journey that was transferred to video in 1998 in the studio archives of J. Fred MacDonald, Professor Emeritus of Northeastern Illinois University, who noted that the message of the film seemed to be quite simple. The Danube Swabians were ready to work. This would be in perfect accord with their long pioneering heritage and represents a legacy still in America, as this chapter hopes to show.

I W

LESSON 2

I Work

work for

must want

I work.

I must work.

I work for my family.

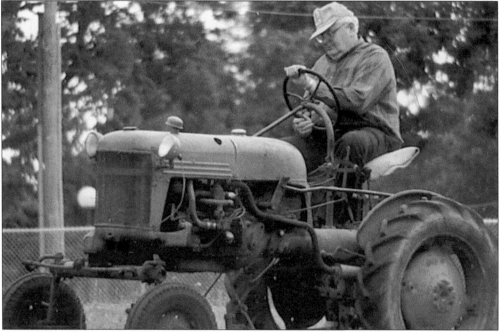

PAUL BELA. Born in the Batschka, he keeps an old tractor "in trim" as he makes a mowing pass over the American Aid Society picnic grounds in Lake Villa, Illinois, during the summer of 1996. (Photograph courtesy of Raymond Lohne.)

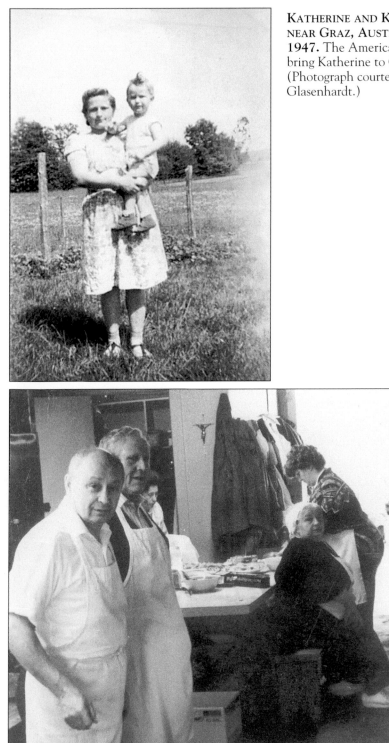

KATHERINE AND KARL GLASENHARDT, NEAR GRAZ, AUSTRIA, SPRINGTIME 1947. The American Aid Society would bring Katherine to Chicago in 1955. (Photograph courtesy of Katherine Glasenhardt.)

KATHERINE GLASENHARDT. Glasenhardt can be seen working in the Lake Villa summer kitchen in 1997. (Photograph courtesy of the Raymond Lohne.)

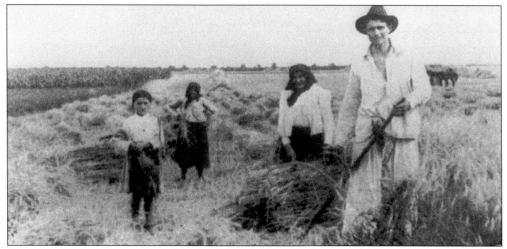

KERNEI, C. 1920. This photo shows the "cutting time" of the wheat harvest in the Batschka. (Photograph courtesy of *Kernei in der Batschka.*) Sebastion Leicht once wrote the following:

> Satter Boden, reiche Ernte und ein Mensch
> der sich harmonisch in die Komposition einfügt.
> Noch passt alles zusammen,
> Fleiss, Frucht, Freude und Friede.

> Nourished soil, rich harvest, and a person
> who fits himself harmoniously into the picture.
> Soon everything comes together,
> Diligence, Fruit, Joy and Peace.

JOE ABT, CINCINNATI OKTOBERFEST, 1989. (Photograph courtesy of the Cincinnati Donauschwaben.)

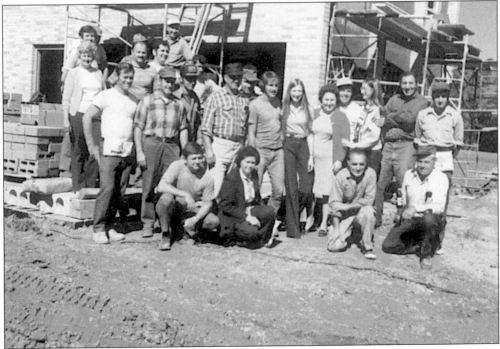

CINCINNATI. This photo shows the construction crew of the Cincinnati Danube Swabian clubhouse in 1975. (Photograph courtesy of the Cincinnati Donauschwaben

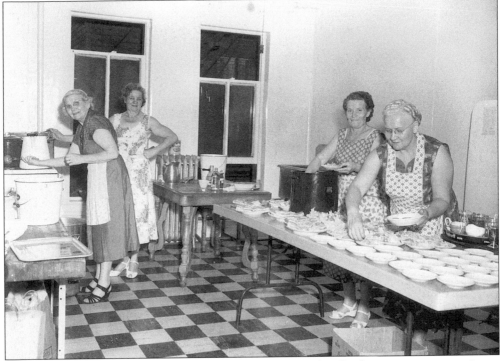

CHICAGO, AUGUST 3, 1957. This photo shows Danube Swabian women preparing a "clubhouse" meal. (Photograph courtesy of the American Aid Society.)

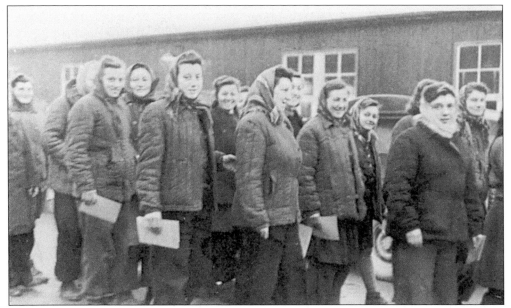

RUSSIA, C. 1950. This photograph captures a rare scene from Russia, before release from forced labor. In typical fashion, it appears Danube Swabian workers may even have distinguished themselves in enslavement. (Photograph courtesy of the Adam Ackermann, *Kernei in der Batschka*.)

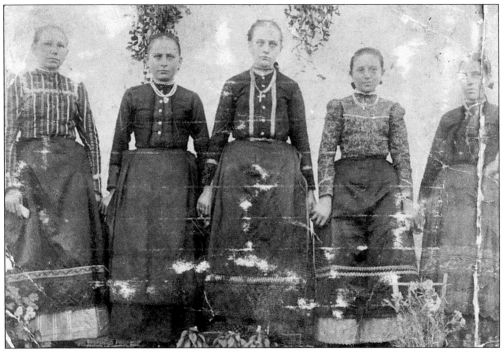

GORJANI, C. 1918. This photograph shows some young women of the village, holding hands. (Photograph courtesy of Katherine Glasenhardt.)

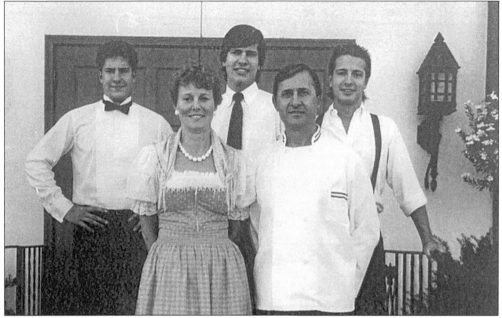

ROBERT TSCHURTZ AND SONS. The Tschurtz's are in front of Fritzl's, the restaurant he established for them in Lake Zurich, Illinois. The sons are, from left to right, Peter, Rob, and Gerhardt. (Photograph courtesy of the Tschurtz family.)

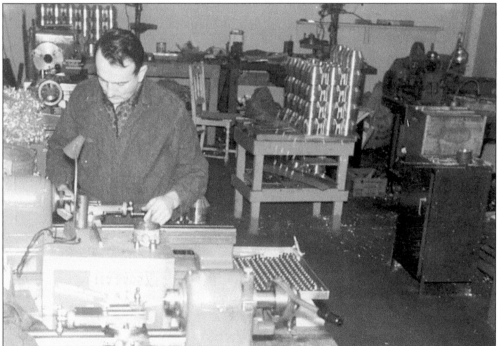

MICHAEL FISCHER. Michael and Anna Fischer, both born in Klein-Betschkerek, Romanian Banat, created the Point Precision Corporation. They are especially proud of the pieces they made for NASA's Lunar Module. (Photograph courtesy of the German-Romanian Society of America, College Point, New York.)

Nikolaus Brustl, der Brotbächer. The "Bread Baker," his wife, and his child appear in this 1927 photograph in St. Hubert. (Photograph courtesy of *Heimatbuch der drei Schwestergemeinden*.)

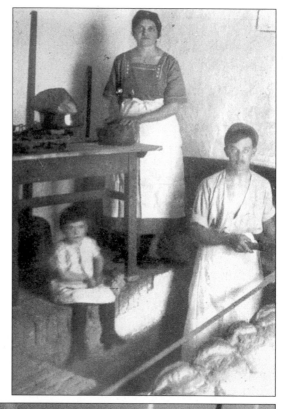

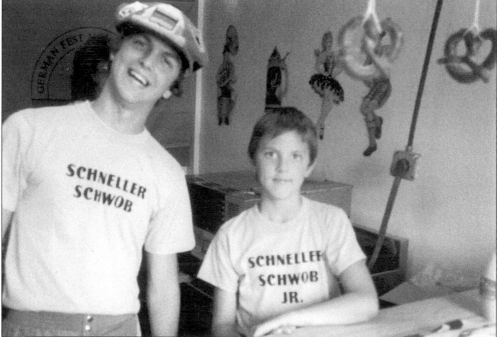

Tim Kretschmann and Andy Wagner. These two sell pretzels at Oktoberfest. (Photograph courtesy of the Milwaukee Donauschwaben.)

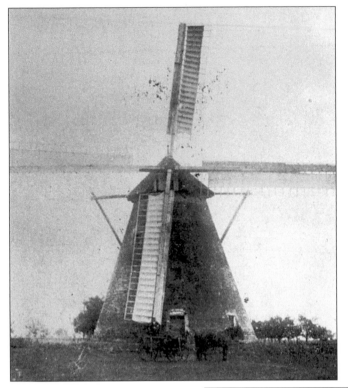

SOLTUR. The local windmill can be seen in this image. (Photograph courtesy of *Heimatbuch der drei Schwestergemeinden.*)

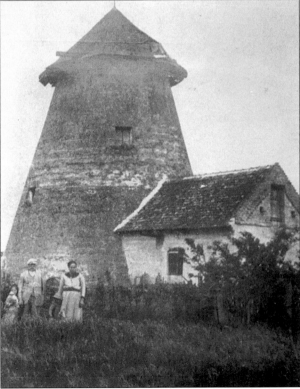

ST. HUBERT, C. 1927. This motorized mill was owned by Josef Rettler. (Photograph courtesy of *Heimatbuch der drei Schwestergemeinden.*)

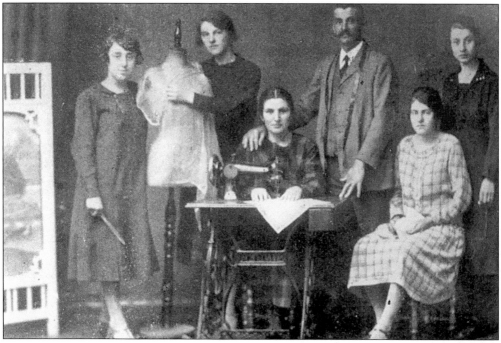

JOHANN HALLOF. Seamstresses can be seen in Hallof's shop in St. Hubert, *c.* 1927. (Photograph courtesy of *Heimatbuch der drei Schwestergemeinden.*)

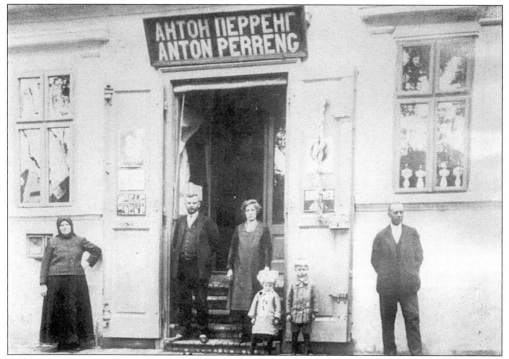

ANTON PERRENG, KAUFMANN. The merchant can be seen with his family in St. Hubert, *c.* 1927. (Photograph courtesy of *Heimatbuch der drei Schwestergemeinden.*)

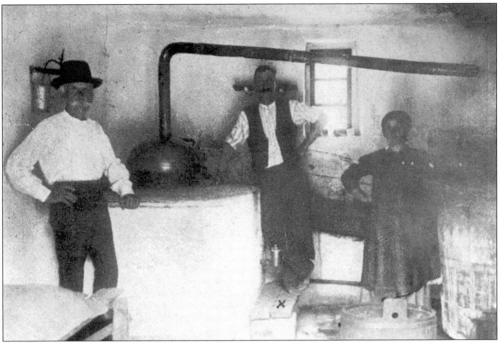

WILHELM WOTTRENG. The owner of the St. Hubert *Schnappsbrennerei* (schnapps brewery) was photographed with his family, *c.* 1927. (Photograph courtesy of *Heimatbuch der drei Schwestergemeinden.*)

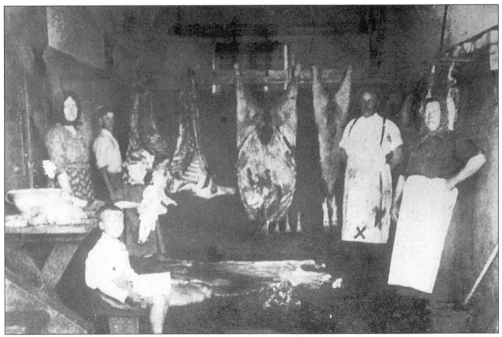

STEFAN PERRENG. Owner of the St. Hubert *Fleischbauerei* or butcher shop, Stefan Perreng, is pictured here with his family, *c.* 1927. (Photograph courtesy of *Heimatbuch der drei Schwestergemeinden.*)

Four
WE NEED FARMERS

The Empress of Russia, Catherine the Great, could make the same admission as could the Empress of Austria-Hungary, Maria Theresa, who also found it necessary to offer certain incentives to young Catholic Germans willing to get married and migrate. Tragically, these inducements to immigrate would entice the Germans to rebuild a land they would eventually be driven from.

Chopping Hay In Arizona

LESSON 22

We Need Farmers

farm who men
post office order
would change

A farm is a place in the country.
Joe works on a farm.
He has some money.
He wants a money order.
He can buy a money order at the post office.
The men who work on farms are farmers.
They like farm work.
They would not change places with men who work in the city.
Farmers grow food for all the people.
City people buy the food.

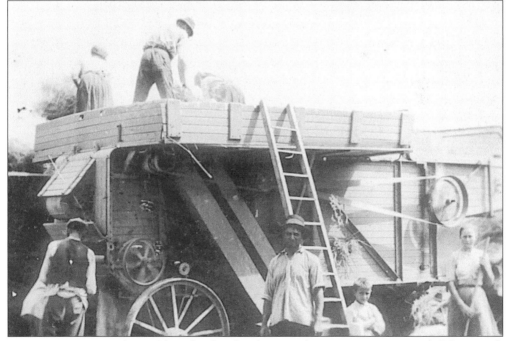

GORJANI, C. 1942. Johann Glasenhardt's threshing machine was steam powered. (Photograph courtesy of Katherine Glasenhardt.)

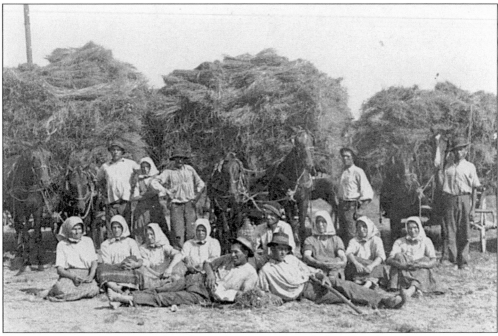

TOMASCHANZI, C. 1920. In this photo, farmers pose with flax they have harvested around Gorjani. (Photograph courtesy of *Heimatbuch Tomaschanzi-Gorjani*.)

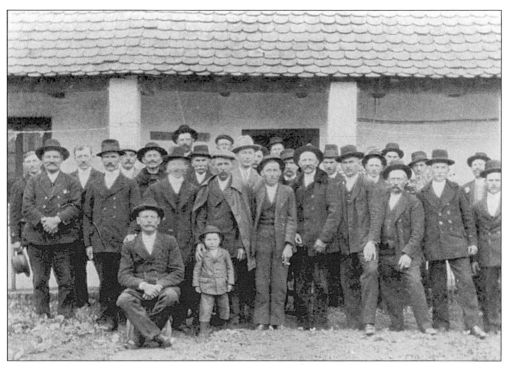

GORJANI, C. 1930. The members of the German Agricultural Association pose for a photograph. This is simply a pooling of wisdom about farming. (Photograph courtesy of *Heimatbuch Tomaschanzi-Gorjani*.)

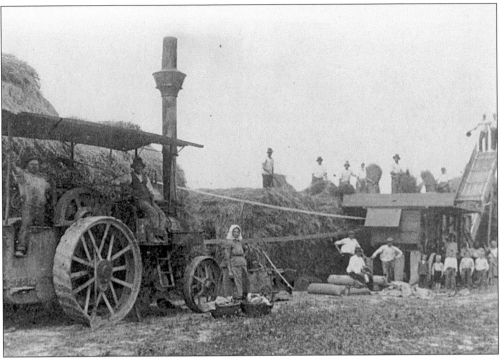

TOMASCHANZI, C. 1920. Threshing in the open field can be seen in this image. (Photograph courtesy of *Heimatbuch Tomaschanzi-Gorjani*.)

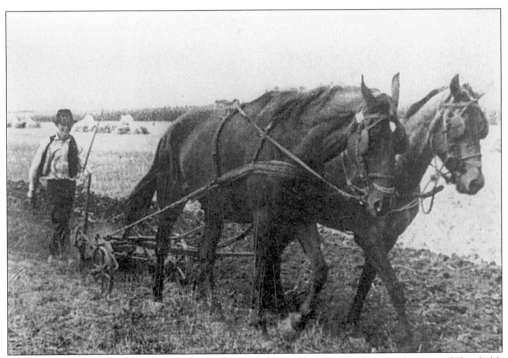

KERNEI, C. 1927. One essential element of farming has always been the plowing of the field. (Photograph courtesy of *Kernei in der Batschka*.)

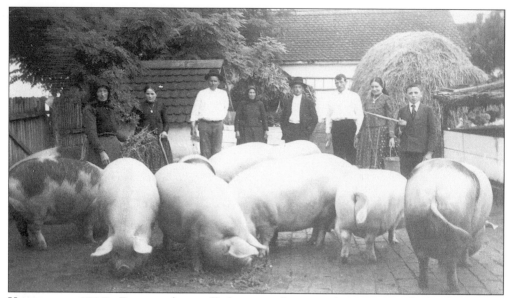

KERNEI, C. 1927. Farmers show off the pigs they are fattening until slaughter time. (Photograph courtesy of Michael Stöckl.)

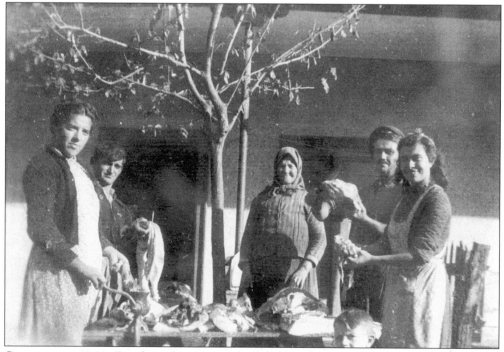

GORJANI, C. 1941. People make sausages by hand in this image. (Photograph courtesy of Katherine Glasenhardt.)

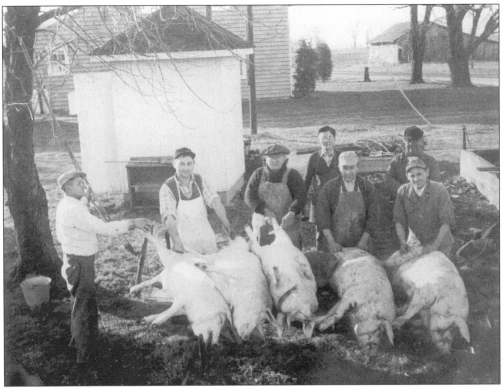

ST. LOUIS, 1957. These images were part of a series of snapshots entitled "slaughter to sausage." (Photograph courtesy of Mike Wendl, St. Louis, Missouri.)

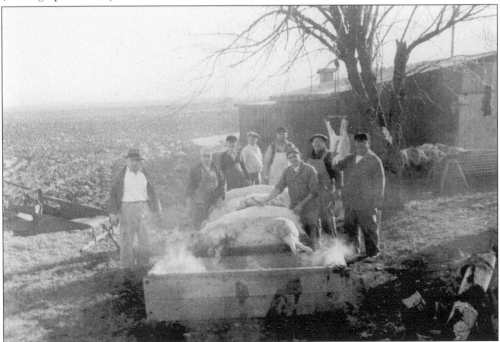

ST. LOUIS, 1957. (Photograph courtesy of Mike Wendl, St. Louis, Missouri.)

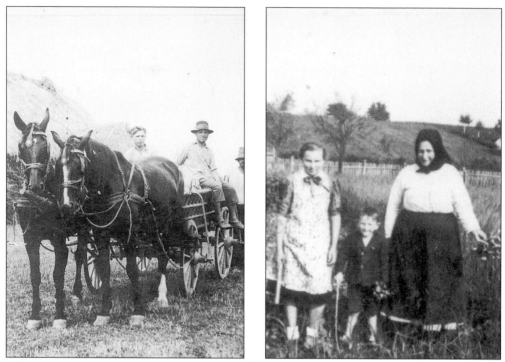

Left: **GORJANI, C. 1943**. Wagons and men can be seen at Glasenhardt's threshing machine in Gorjani, before it was burned down by the Partisans. (Photograph courtesy of Katherine Glasenhardt.) *Right:* **GLASENHARDT GARDENS, C. 1942.**

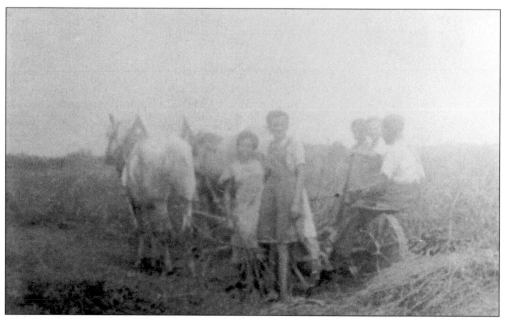

GRAZ, 1947. Katherine Glasenhardt is the girl in the center of the photograph, harvesting crops again. (Photograph courtesy of the Courtesy of Katherine Glasenhardt.)

42

Five
OUR HOMES

The realities of the Expulsion require us to imagine losing a home forever in moments. If you were ordered out in ten minutes, what would you do? What would you take? A precious heirloom? Money? Food? Clothing? Survivors I have interviewed thus far can not seem to forget their homes. Indeed, their homes are all the more in mind due to the manner in which they were lost.

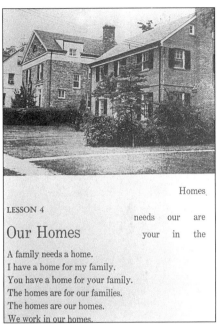

Homes

ANNEROSE WELSCH. Annerose can be seen with her two brothers, Harald and Gerhard, on Wilton Avenue, Chicago, during the summer of 1950. They escaped to Austria from the Russian-occupied village of Sankt Andreas in the Romanian Banat in 1947, with money sent by an aunt in the U.S. They made the journey on foot. (Photograph courtesy of Annerose Görge.)

LESSON 4

needs our are

Our Homes

your in the

A family needs a home.
I have a home for my family.
You have a home for your family.
The homes are for our families.
The homes are our homes.
We work in our homes.

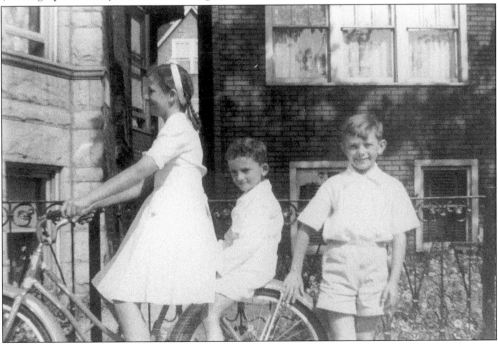

WENDEL AND NANA FEITER'S HOME, MILWAUKEE, WISCONSIN. The Milwaukee Donauschwaben, pictured here, toured Germany together in 1994. They used the Feiter's home as a "dream house" backdrop for the trip postcard. Wendl Feiter is a Danube Swabian who built a wheelchair manufacturing business. (Photograph courtesy of the Milwaukee Donauschwaben.)

SUSANNA STACHLER. She is pictured with her parents, Johann and Susanna, in their Chicago apartment, not long after they arrived from the refugee camp in Austria in 1952. (Photograph courtesy of Susanna Tschurtz.)

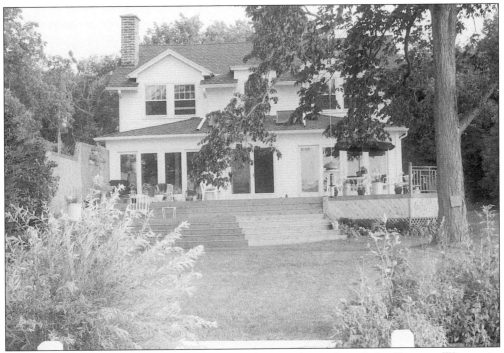

SUSANNA TSCHURTZ. Susanna's house, seen here, is located on Lake Geneva, Wisconsin. (Photograph courtesy of Susanna Tschurtz, 1998.)

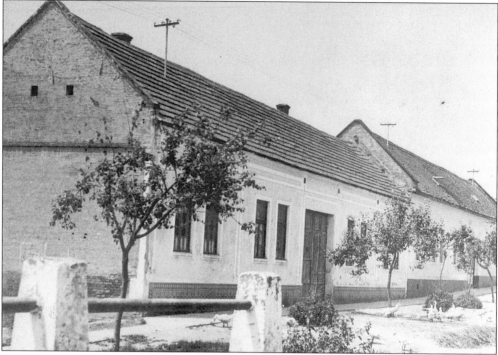

GORJANI, C. 1924. This house belonged to the Glasenhardt family. (Photograph courtesy of Katherine Glasenhardt.)

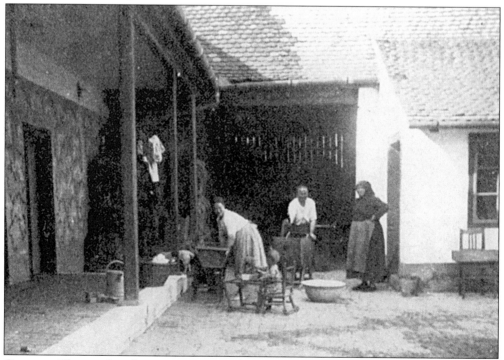

GORJANI. This is what the interior courtyard areas looked like. It is wash day in this c. 1927 photograph. (Photograph courtesy of *Heimatbuch Tomaschanzi-Gorjani*.)

GORJANI, C. 1950. George Kralic and family, the new inhabitants, stand outside the former Glasenhardt house. (Photograph courtesy of Katherine Glasenhardt.)

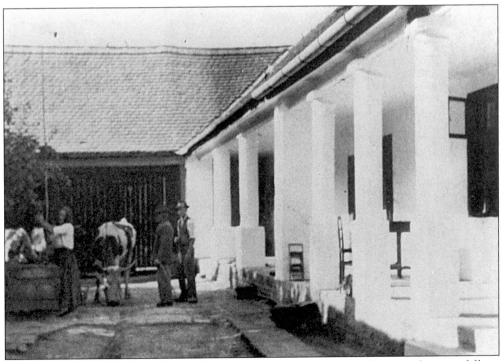

GORJANI, C. 1920. Life on a German homestead involved nurturing the animals as carefully as people. (Photograph courtesy of *Heimatbuch Tomaschanzi-Gorjani.*)

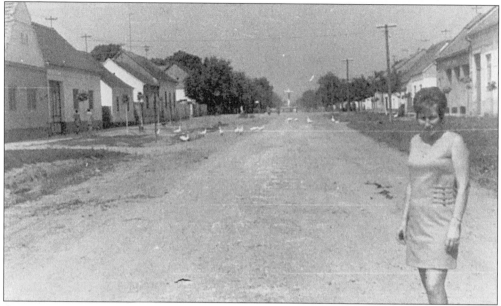

GORJANI, C. 1960. This picture shows the main street of the village, leading out to the fields. (Photograph courtesy of *Heimatbuch Tomaschanzi-Gorjani.*)

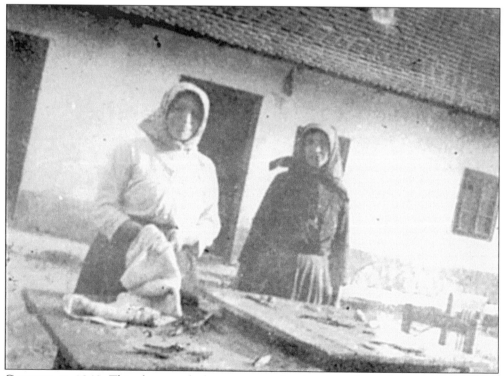

GORJANI, C. 1942. This photograph shows women cleaning utensils on the main street of the village. (Photograph courtesy of Katherine Glasenhardt.)

ANTON HEIM. The flower garden of Anton Heim and his wife can be seen in this image taken in St. Hubert, c. 1927. (Photograph courtesy of *Heimatbuch der drei Schwestergemeinden.*)

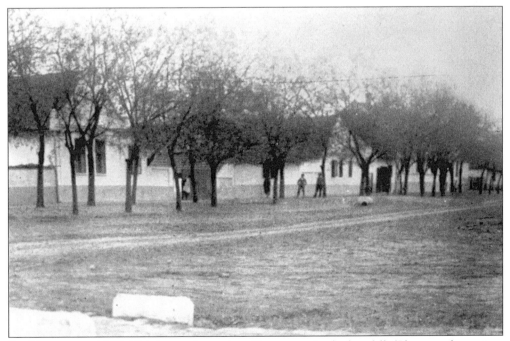

ST. HUBERT, C. 1927. This image shows the village street in the late fall. (Photograph courtesy of *Heimatbuch der drei Schwestergemeinden.*)

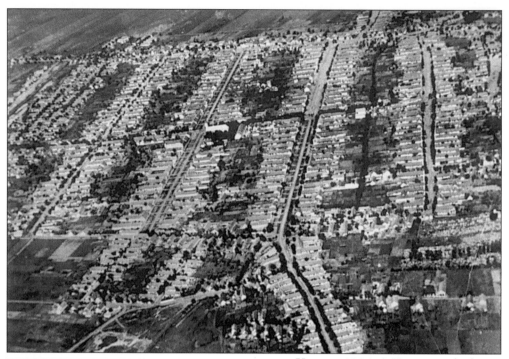

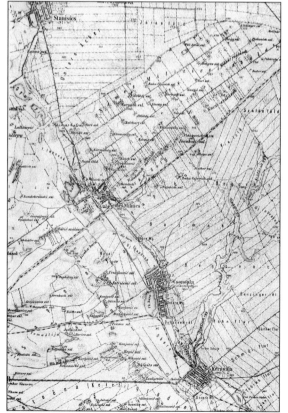

KERNEI, 1931. A Kerneir made this unauthorized photograph while serving in a Yugoslavian military aircraft. (Photograph courtesy of Michael Stöckl; Map courtesy of the Josef Bleichert Archive, Karlsdorf, Banat.)

Six
WE OWN LAND

An analysis of the Donauschwaben from this perspective remains a task still before this researcher, but one thing is likely to come out of such a study. Wherever they are, from Brazil to Canada, from Germany to America, they are landowners, and their impact in America has not been studied yet.

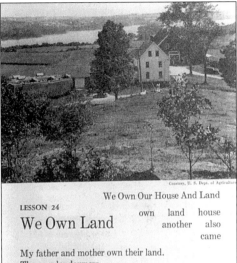

We Own Our House And Land

LESSON 24

We Own Land

own land house
another also
came

My father and mother own their land.
They are landowners.
People who own land are landowners.
They own the house on the land.
They are home owners.
People who own their houses are home owners.
Father came here from another country.
Mother also came from another country.
They came to find a better place in which to live.

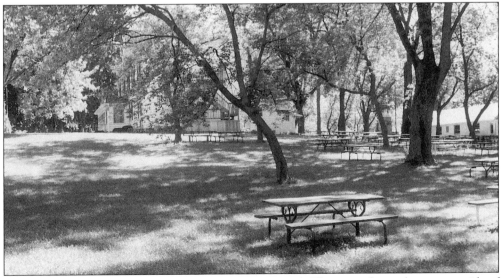

AMERICAN AID SOCIETY, LAKE VILLA, ILLINOIS, 1996. This view shows the western side of the former German-Hungarian Old People's Home. (Photograph courtesy of Raymond Lohne.)

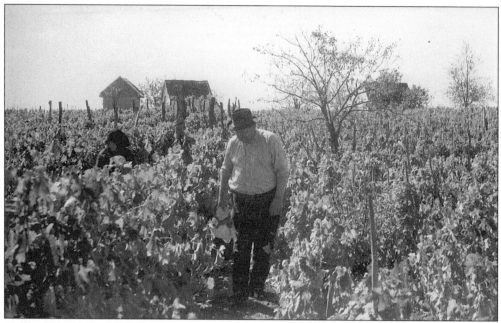

KERNEI, C. 1940. This photograph shows crops growing in the Batschka. An unidentified farmer and his wife walk through the plot. (Photograph courtesy of Michael Stöckl.)

KLEINSTAPAR, C. 1930. This is the tiny village where Michael Stöckl grew up. (Photograph courtesy of Michael Stöckl.)

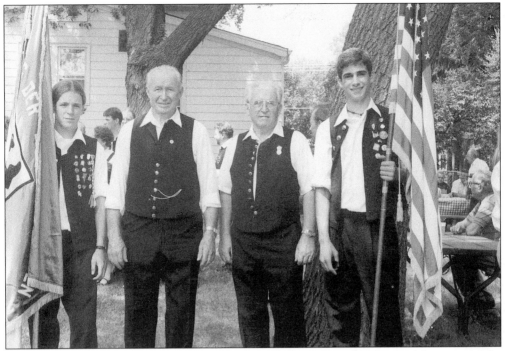

LAKE VILLA, ILLINOIS, 1998. During a Day of the Donauschwaben celebration at the American Aid Society picnic grounds, the former president, Stefan Kunzer, and President Nikolaus Schneider pose with two young men. The use of the land seems to have changed from growing food to nurturing communal ties. (Photograph courtesy of the Vereinigung der Donauschwaben of Chicago.)

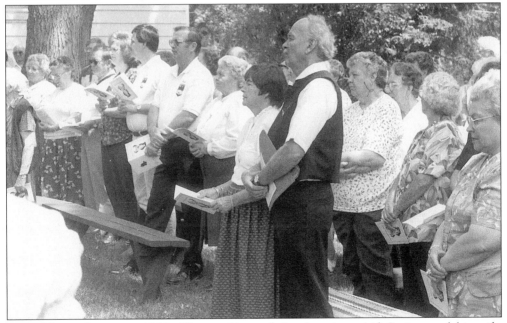

LAKE VILLA. ILLINOIS, 1999. The president of the American Aid Society and his wife, Elizabeth, listen to the priest on Memorial Day. (Photograph courtesy of Raymond Lohne.)

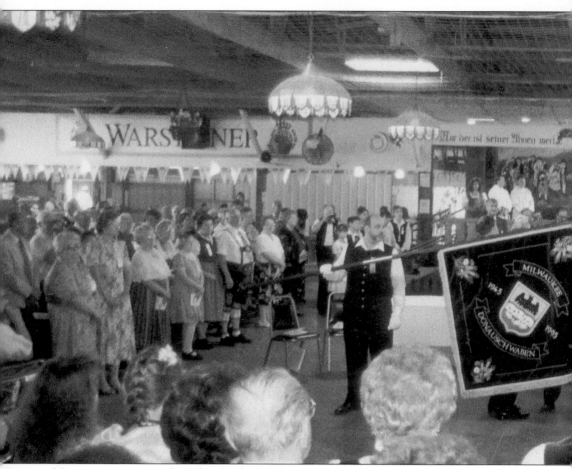

MILWAUKEE, 1995. The Schwabenhof of the Milwaukee Donauschwaben can be seen during the Fahnenweihe and 50th Anniversary of the club, wherein the flag is blessed in a special

service. The sign behind the stage reads, "Only he is worthy of his ancestors whose customs he truly honors." (Photograph courtesy of the Kretschmann, Milwaukee Donauschwaben.)

OLMSTEAD TOWNSHIP, OHIO. In 1970, Danube Swabian Americans bought the old Ritter farm and built a home for themselves on it. Renamed Lenau Park, in honor of one of their greatest poets, construction began in the early 1980s, largely by volunteer labor. (Photograph courtesy of the Deutsch-Amerikanisches Kulturzentrum.)

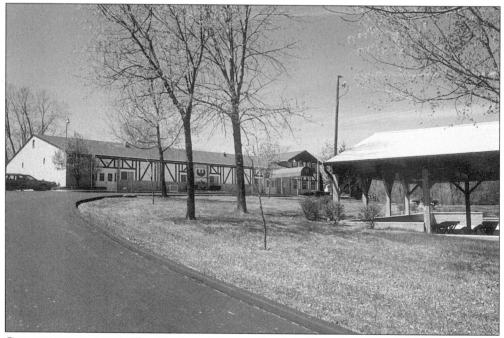

CINCINNATI, C. 1980. The Cincinnati Donauschwaben Haus, begun in 1975 and completed in 1978, was built entirely by the members. (Photograph courtesy of the Cincinnati Donauschwaben.)

Seven

GOOD NEIGHBORS

In 1983, Sebastian Leicht published *Weg der Donauschwaben: Graphischer Zyklus*. In it, he made the following bold assertion: *Ein Antisemitismus oder ein Judenhass bestand unter den Donauschwaben nicht*. Anti-semitism and hatred of Jews could find no place with the Donauschwaben.

Perhaps the material realities of a multi-ethnic empire persuaded the Donauschwaben not to be anti-semitic, or perhaps they took the fundamental lessons of Christianity more seriously, but over 250 years of peaceful co-existence among Serbs, Croats, Muslims, and Jews, to name but a few, is eloquent enough evidence of the truth. Until the arrival of Hitler and Stalin, the Donauschwaben were considered "good neighbors."

Good Neighbors

LESSON 25

neighbors why
her kind if
call yes

Good Neighbors

Do we like our neighbors?
Yes, we do like them.
Why do we like our neighbors?
They are good and kind.
If we have too much work, we can call on them to help us.
If they need help with their work, we help them.

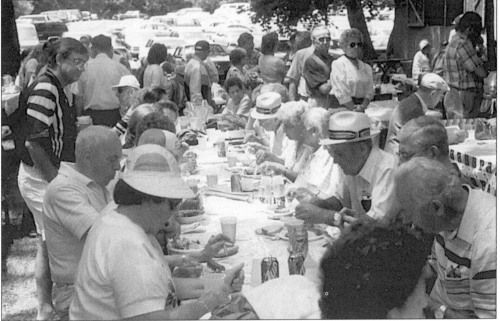

LAKE VILLA, ILLINOIS, 1997. The Chicago German community frequently enjoys the American Aid Society picnic grounds and have been doing so since 1925, when the Old People's Home was first established there. (Photograph courtesy of Raymond Lohne.)

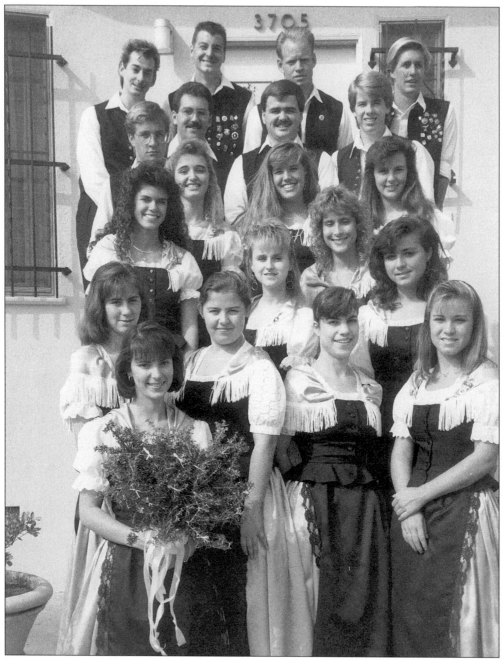

LOS ANGELES, 1990. Seen here is a California Kirchweih. (Photograph courtesy of Chris Balogh, Los Angeles Donauschwaben.)

Ehret das Alter
Streben und Walten
für ein Heim
Der Alten

Honor old age.
Striving for and Managing
a home for the aged.

This cover photograph from the German-Hungarian
Old People's Home in Lake Villa, Illinois, came
from a c. 1940 Christmas brochure. The
complications involved in running such an
establishment eventually forced the closure of the
home. Today, it serves as a museum.

German-Hungarian
OLD PEOPLES HOME
Lake Villa, Ill.

Ehret das Alter

Streben und Walten

Fuer ein Heim

Der Alten

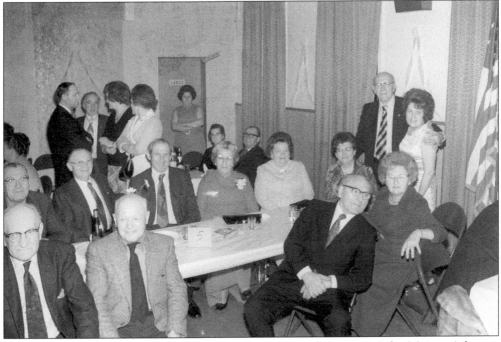

CHICAGO, 1974. This party was held by the American Aid Society in John Meiszner's honor.
(Photograph courtesy of Helen Meiszner.)

59

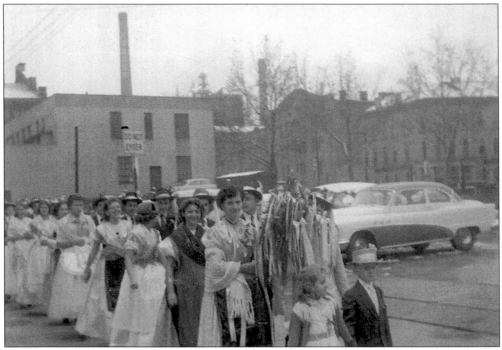

KATHY ROCH AND MICHAEL LIND JR. Roch and Lind lead the procession from St. Joseph of Nazareth Church to Banater Hall during Cincinnati's 1955 Kirchweihfest. (Photograph courtesy of the Cincinnati Donauschwaben.)

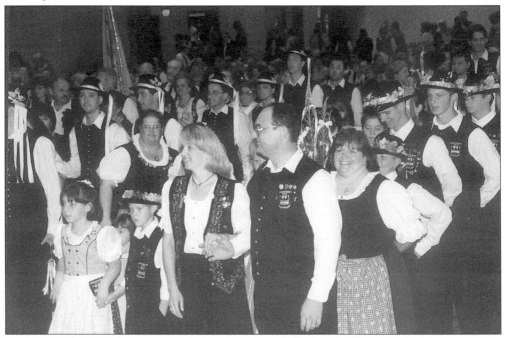

CLEVELAND, OHIO. This photograph was taken in Holzer Halle, the German-American Cultural Center in Lenau Park, Cleveland, Ohio. (Photograph courtesy of the Cleveland Donauschwaben.)

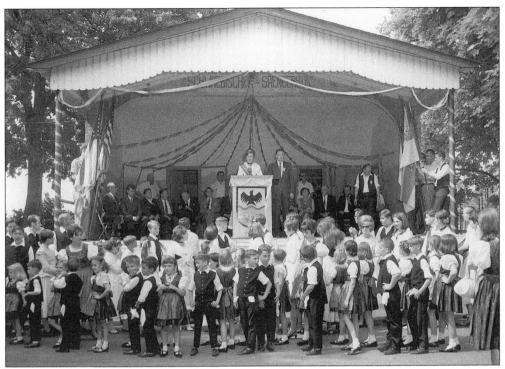

NEW YORK CITY, 1968. The Trachtenkönigin greets her youngest subjects and guests at a Day of the Homeland Celebration. (Photograph courtesy of Eva Mayer, College Point, New York Donauschwaben.)

NEW YORK, 1998. Donauschwaben of New York take a "turn around" at one of their celebrations. (Photograph courtesy of the New York Donauschwaben.)

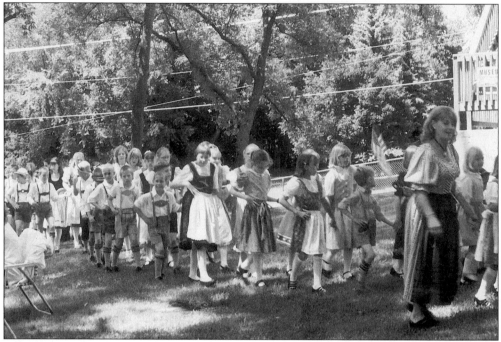

LAKE VILLA, ILLINOIS, 1998. American Aid Society children begin their turn around the grounds in this picture. (Photograph courtesy of Raymond Lohne.)

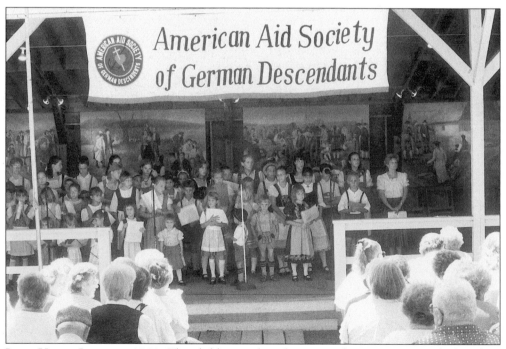

LAKE VILLA, ILLINOIS, 1998. The children end up dancing and singing on stage before their parents and guests. (Photograph courtesy of Raymond Lohne.)

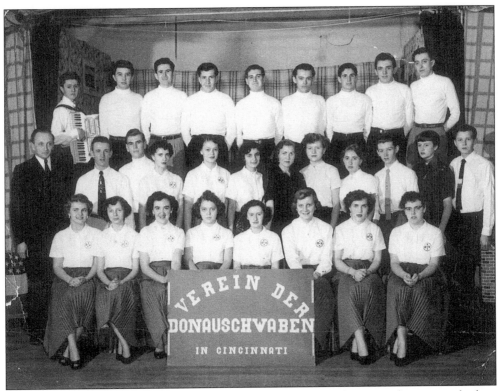

CINCINNATI, 1954. The first youth group of the Danube Swabians can be seen with their teacher Anton Blassmann. (Photograph courtesy of the Cincinnati Donauschwaben.)

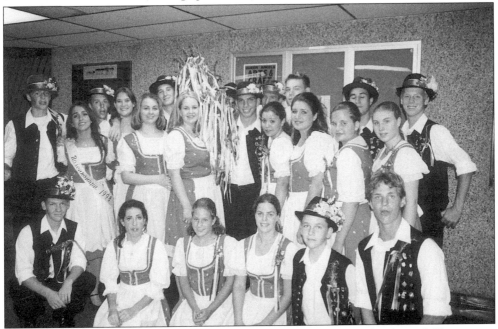

CHICAGO, 1998. The youth group of the Vereinigung der Donauschwaben of Chicago are pictured at their Kirchweih. (Photograph courtesy of Susanna Tschurtz.)

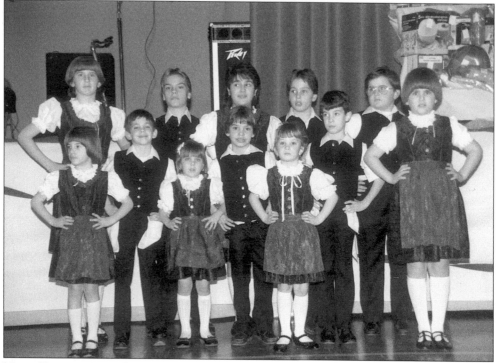

NEW YORK, 1990. DONAUSCHWÄBISCHE KINDERGRUPPE. This is a Danube Swabian children's group performing in front of their parents. (Photograph courtesy of the New York Donauschwaben.)

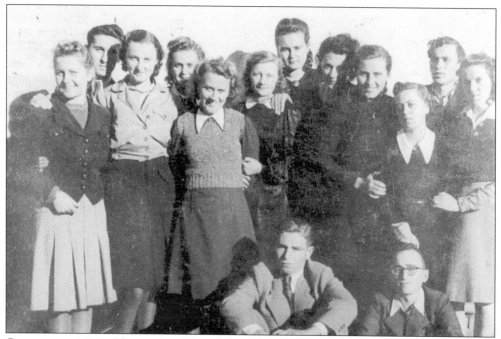

GORJANI, C. 1943. The young adults of the village gather for a snapshot with classmates in wartime Yugoslavia. (Photograph courtesy of Katherine Glasenhardt.)

GORJANI, C. 1943. This is a street scene near the Glasenhardt home. Even the war could not stop everyday life. (Photograph courtesy of Katherine Glasenhardt.)

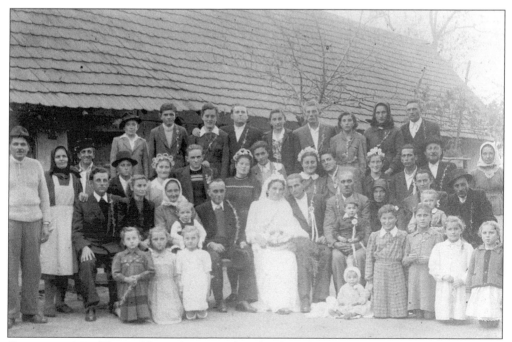

GORJANI, 1943. The wedding of Pepica Glasenhardt is shown above. (Photograph courtesy of Katherine Glasenhardt.)

CHICAGO, OCTOBER 17, 1950. The American Aid Society threw a farewell party for Prof. P. Josef Stefan, seated in rear next to Nick Pesch, who is at the edge of the framed picture. Stefan worked as *Fluchtlingsseelsorger*, or "refugee pastor," in Salzburg, Austria, and had visited all the chapters of the American Aid Societies. (Photograph courtesy of Helen Meiszner.)

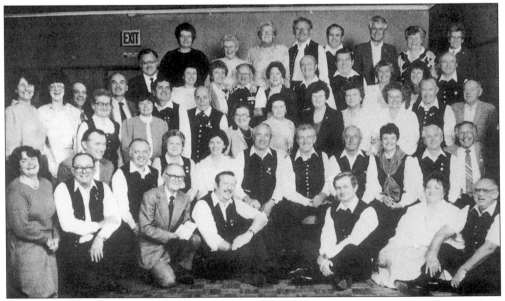

CHICAGO, 1987. Some leading citizens of the Danube Swabians pose for a group photograph in the clubhouse of the American Aid Society. (Photograph courtesy of the American Aid Society.)

KERNEI, C. 1932. JUNGE FRAU IN FESTTRACHT. The young woman appears in festival costume. (Photograph courtesy of *Kernei in der Batschka.*)

RENEE MARIE STEIN, LAKE VILLA, MEMORIAL DAY, 1999. She is the daughter of Josef and Rosina Stein. (Photograph courtesy of Raymond Lohne.)

KARINA KURZHALS AND ERIC WILZBACH. This pair was captured dancing downtown at the Oktoberfest Zinzinnati, 1997. (Photograph courtesy of Cinti, Cincinnati Donauschwaben.)

ELSA WALTERS. Walters (left) appears with friends at John Meiszner's party on February 2, 1974, in Chicago. (Photograph courtesy of Helen Meiszner.)

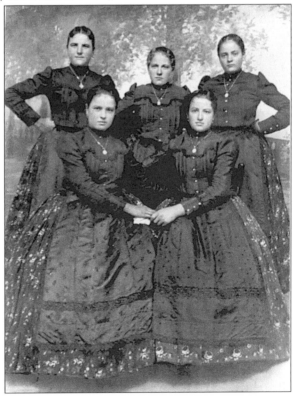

KERNEI, C. 1931. Village girls appear in the photograph above. (Photograph courtesy of Michael Stöckl.)

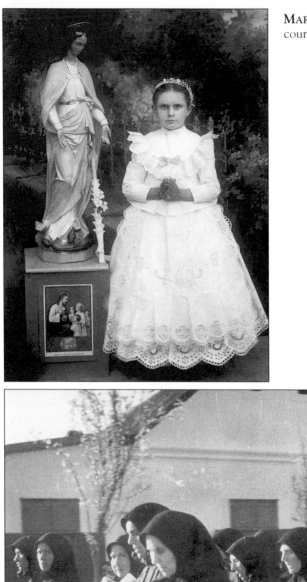

MARIANA STÖCKL. (Photograph courtesy of Michael Stöckl.)

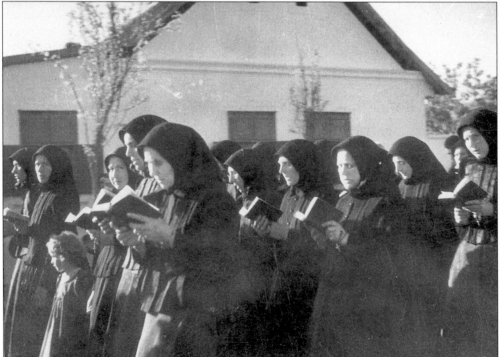

KERNEI, C. 1941. A church procession is pictured here. (Photograph courtesy of Michael Stöckl.)

Eight
MORE ABOUT OUR NEIGHBORS

The Nazarene played an equally important role in the Danube Swabian story of survival, as this chapter hopes to reveal.

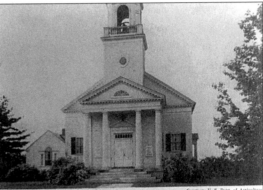

Courtesy, U. S. Dept. of Agriculture

LESSON 26 A Country Church

More About Our Neighbors

of same
years by
as been

Our neighbors do all they can for us.
We like this kind of neighbor.
We all like the same things.
We go to the same church.
We go to the same places for good times.
We have been neighbors for many years.
We like to live by good neighbors.
We try to be as good neighbors as they are.
Our neighbors own their home.
We own our home.
We have lived by the same neighbors for many years.

KERNEI, 1925. Following a fire, the church in Kernei was rebuilt to this state. (Photograph courtesy of Adam Ackermann, *Kernei in der Batschka.*)

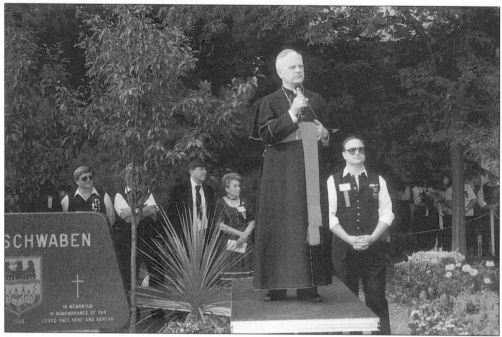

CLEVELAND, OHIO, 1994. Bishop Sebastion Kraeuter of Temesvar, Romania, appeared at the 50th anniversary of the expulsion of the Danube Swabians, a memorial gathering that featured Susanna Tschurtz paintings. (Photograph courtesy of the Cleveland Donauschwaben.)

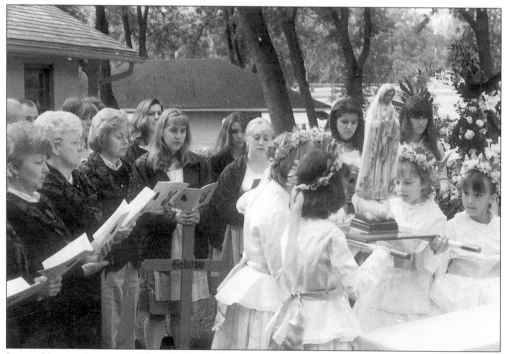

LAKE VILLA, ILLINOIS. The Mother of God girls appeared at the American Aid Society grounds, Memorial Day, 1997. (Photograph courtesy of Raymond Lohne.)

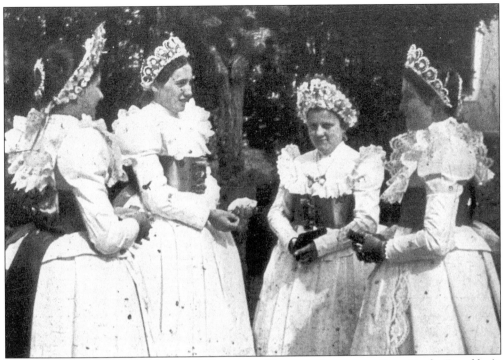

KERNEI, C. 1942. MUTTER GOTTES MÄDCHEN. (Photograph courtesy *Kernei in der Batschka.*)

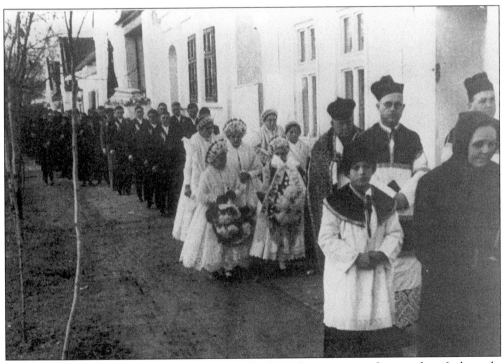

KERNEI, C. 1942. This photograph depicts the funeral procession of an unidentified youth. (Photograph courtesy of *Kernei in der Batschka.*)

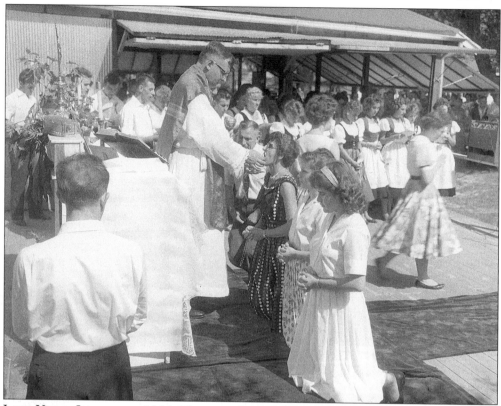

LAKE VILLA, ILLINOIS, C. 1956. These people are taking Communion. (Photograph courtesy of the American Aid Society.)

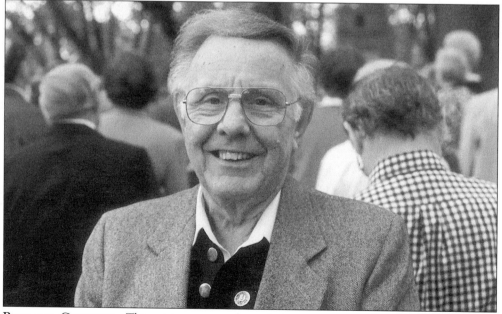

RICHARD GUNTHER. This picture was taken during a mass at the memorial in 1997. (Photograph courtesy of Raymond Lohne.)

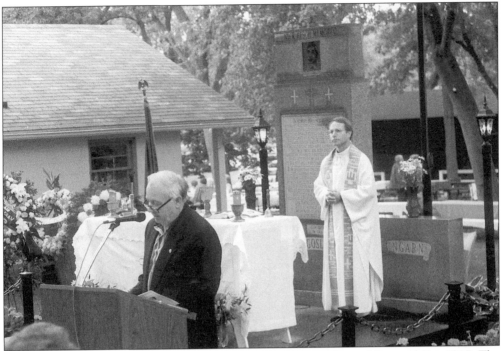

JOSEPH STEIN. The secretary of the American Aid Society spoke on Memorial Day 1997. The priest standing at the Nick Pesch Memorial is Father Langsch, who conducts the mass in German. (Photograph courtesy of Raymond Lohne.)

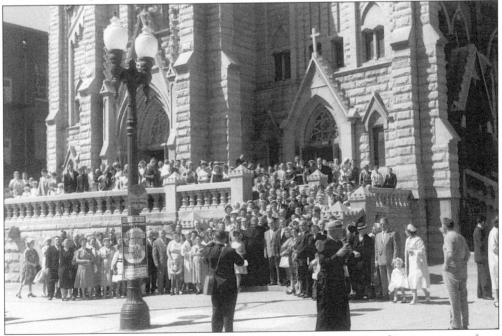

CHICAGO, AUGUST 20, 1961. The Kerneiers can be seen in this image, in front of St. Alphonsus Catholic Church on Lincoln and Wellington. (Photograph courtesy of Michael Stöckl.)

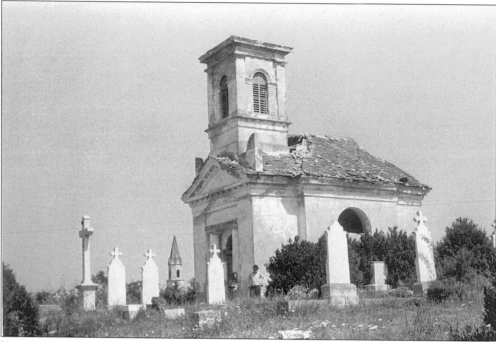

KERNEI, C. 1962. The ruins of the local church and cemetery can be seen above. (Photograph courtesy of Michael Stöckl.)

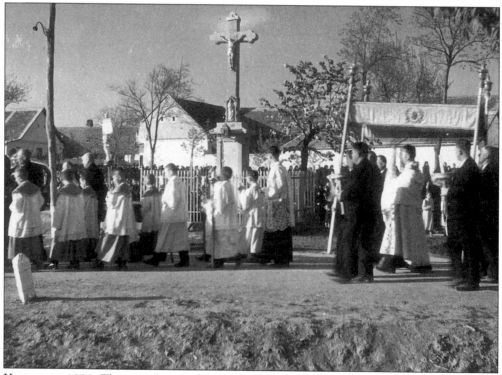

KERNEI, C. 1920. This snapshot is of a church procession of some kind. (Photograph courtesy of Michael Stöckl.)

Nine

WE LEARN

Michael Perman, in *Perspectives on the American Past*, wrote about the "shift of emphasis" in American history, away from an "elitist perspective" to that of the "ordinary and powerless people of American society." He said further that "Historians now assume that the attitudes of the masses of people cannot be dismissed. Those who once seemed insignificant are no longer seen as passive non-participants in history but are believed, in their own way, to have influenced and even shaped it." This assertion would be amply proved in the case of the Danube Swabians.

courtesy, Americanization School, Washington, D. C.

We Learn

LESSON 7

We Learn

learn things
groups church
what right many

People must learn many things.
We like to learn in groups.
The family is a group.
The church is a group.
Children learn what is right in the home and in the church.
Father and mother help the children to learn the right things.
People learn together what is right.
People want to learn.
People need to learn what is right.

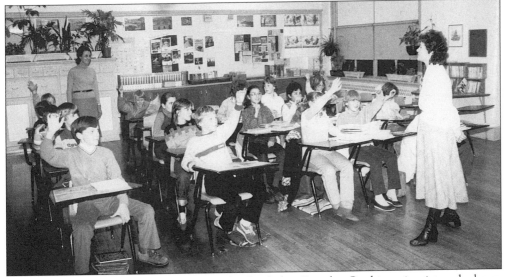

CLEVELAND, C. 1980. The German school of the Danube Swabians is pictured above. (Photograph courtesy of the Cleveland Donauschwaben.)

NEULAND. The newspaper, which Leopold Rohrbacher created in Salzburg, Austria, on May 15, 1948, was titled *Neuland.* His keynote article was entitled *"Die Einbürgerung der Heimatlosen,"* or the "Naturalization of those without a Homeland." The Danube Swabians had no other voice as loud and clear as Leopold Rohrbacher's. This is the article in which he broke the bad news to his countrymen that they were locked out of the care of the International Refugee Organization.

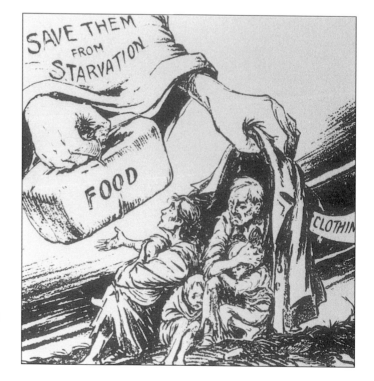

SAVE THEM FROM STARVATION, C. 1948, ARTIST UNKNOWN. This is the masthead drawing of the American Aid Societies' Bulletin.

NICK PESCH, JANUARY 22, 1949. The president of the American Aid Societies steadfastly refused to take that expensive trip to Europe, preferring instead to use the money on care packages and postage. It was a symbolic gesture, and a firm one. Alexander Weissmann, a Jewish gentleman who owned the travel agency at 644 W. North Avenue in Chicago that was used by the Donauschwaben to send packages and bring over eligible immigrants, decided to arrange for the trip at his own expense, solving their problem. Because of Weissman's generosity, he was called "a real and true friend of the Donauschwaben" in the June 1949 American Aid Societies' Bulletin, which confirmed, if only a little, Leicht's finding that there is no "anti-Jewishness," as Richard Levy might prefer to term it, among the Donauschwaben.

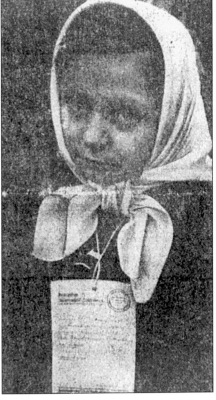

NEULAND. This photograph was run in the *Neuland* with the following caption: *Verschickt-ohne Heimat, ein Bild, das zum Sinnbild für eine ganze Epoche wurde.* This translates literally to, "Sent in, without address, a picture that became a 'meaning picture' of an entire epoch."

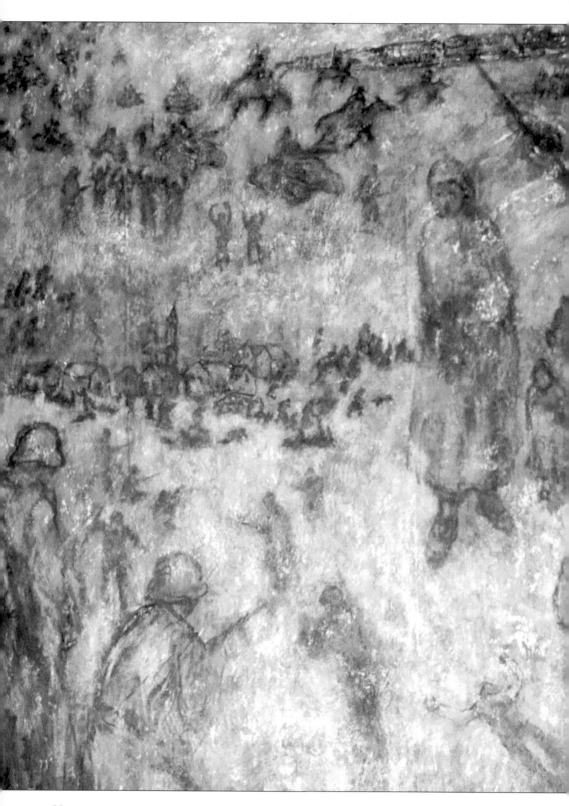

SUSANNA TSCHURTZ, WAR SERIES, ACRYLIC ON CANVAS. This huge and haunting acrylic painting is approximately six foot square. In *A Terrible Revenge: The Ethnic Cleansing of the East European Germans 1944–1950*, Alfred de Zayas quotes Susanna as saying, "I already knew what war was. It was shooting, guns, tanks, airplanes, and fire. I remembered the Russian planes attacking our trek; the broken wagons, the fallen and wounded horses, the fear I felt when we ran to hide in the fields." (Photographed by artist.)

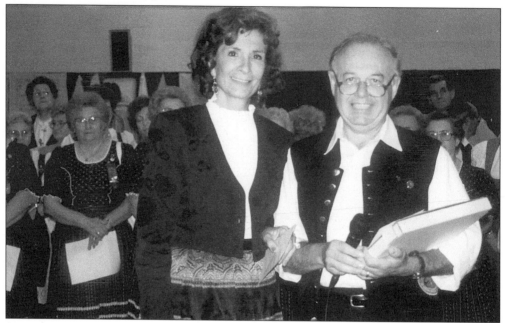

SUSANNA TSCHURTZ. Joseph Stein presented Tschurtz the Kulturpreis at the Day of the Donauschwaben, the 50th anniversary of the Expulsion, in Cleveland, Ohio, in 1994. (Photograph courtesy of Joseph Stein.)

Heimatbote

Das Sprachrohr der Donauschwaben in Nordamerika — The Voice of the Danube Swabians in North America

Jahrgang 38 —— No 453 Toronto, Ontario —— November 1998 Preis: $2.50

Ausstellung in der U.S. Senate Russel Rotunda

ETHNISCHE SÄUBERUNG DIE VERTREIBUNG DER DEUTSCHEN AUS DEN OST- UND SÜD-OSTSTAATEN

Das Institut für Deutsch Amerikanische Beziehungen (The Institute for German American Relations) und die Donauschwäbische Stiftung stellten eine eindrucksvolle und geschichtstreue Ausstellung über die zwangsvolle Vertreibung der deutschen Zivilbevölkerung, unter Drohung erschossen zu werden, aus ihren Häusern und aus ihrer Heimat, wo ihre Ahnen sich vor dreihundert Jahren niedergelassen hatten. Nach Herrn Richard Holbrooke, Assistent des Innenministers der Vereinigten Staaten von Amerika, ist dies die Defination der ethnischen Säuberung.

Die außergewöhnliche Ausstellung fand vom 12. Oktober 1998 bis 16. Oktober 1998 im U.S. Senat, Russell Rotunda, in Washington, D.C. statt. Der Eintritt war frei. Unter der Schirmherrschaft von Senator Rick Santorum und Mikulski.

HEIMATBOTE, NOVEMBER 1998. The voice of the Danube Swabians in America announces the exhibit in the Senate Russel Rotunda Building entitled "Ethnic Cleansing," which featured Susanna's huge and haunting paintings.

EVE KOEHLER. The Kulturpreis-winning author of *Seven Susannahs: Daughters of the Danube*, Eve Koehler, can be seen at left. (Photograph courtesy of Eve Koehler.)

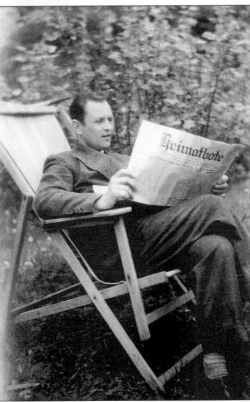

MICHAEL STÖCKL. With their own organizations and their own newspapers, the Donauschwaben intelligentsia kept themselves informed even while the rest of the world went on ignoring them. In the end, it would not be possible to silence them, even at the highest levels of American government. Here, Stöckl reads the *Heimatbote,* near Graz, Austria, 1954.

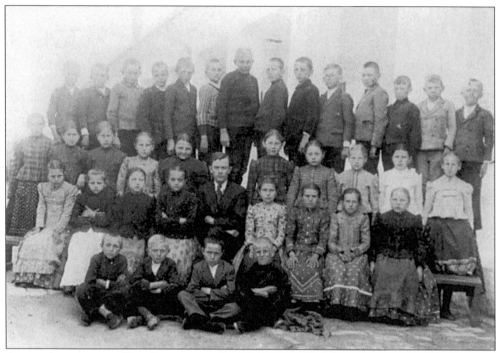

ADAM ACKERMANN. The historian and teacher appears with students in Kernei in 1935. (Photograph courtesy of *Kernei in der Batschka*.)

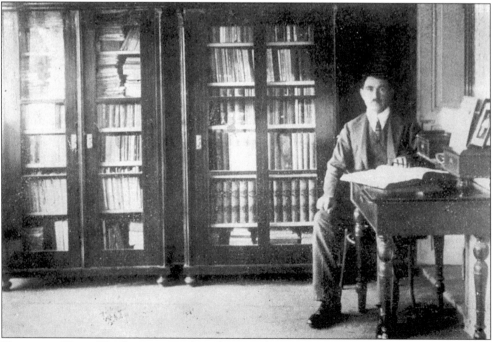

NIKOLAUS HESS. The historian and teacher can be seen in his library in St. Hubert, 1927. (Photograph courtesy of *Heimatbuch der drei Schwestergemeinden*.)

TOMASCHANZI, C. 1942. Shown above is a Deutscher Kindergarten class with their teachers. (Photograph courtesy of *Heimatbuch Tomaschanzi-Gorjani.*)

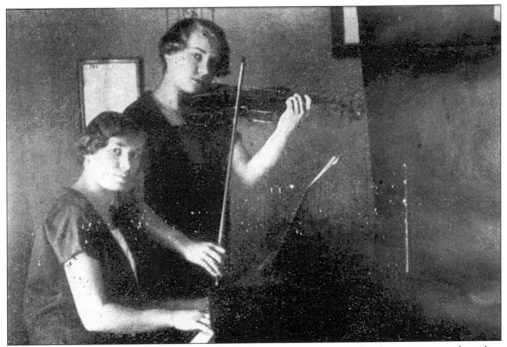

ST. HUBERT, C. 1927. Marianna and Maria Perreng pose with their piano and violin. (Photograph courtesy of *Heimatbuch der drei Schwestergemeinden.*)

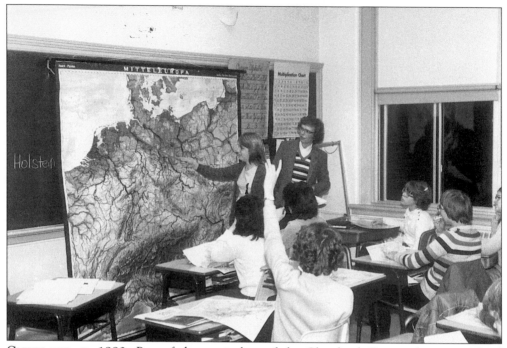

CLEVELAND, C. 1980. Part of the curriculum of the Cleveland German language school includes lessons on geography. (Photograph courtesy of the Cleveland Donauschwaben.)

JOHNNIE WEISSMÜLLER. Perhaps the most powerful evidence that the Danube Swabians were "good neighbors," beyond their long historical co-existence with diverse peoples, is the fact that once they had knowledge of evil being committed in Yugoslavia, they acted upon that information, as the story of the good samaritan had taught them to do. This September 10, 1949, *Neuland* article relates how, during the war, a sergeant of the Romanian Gendarmerie sought Weissmüller among the men of the village of Freidorf, where his parents came from, so they could draft him.

Ten

WE HELP EACH OTHER

In the novel 1984, George Orwell wrote the following: "The terrible thing that the Party had done was to persuade you that mere impulses, mere feelings, were of no account, while at the same time robbing you of all power over the material world. When once you were in the grip of the Party, what you felt or did not feel, what you did or refrained from doing, made literally no difference. Whatever happened you vanished, and neither you nor your actions were ever heard of again. You were lifted clean out of the stream of history. And yet to the people of only two generations ago, this would not have seemed all important, because they were not trying to alter history. They were governed by private loyalties which they did not question. What mattered were individual relationships, and a completely helpless gesture, an embrace, a tear, a word spoken to a dying man, could have value in itself. The proles, it suddenly occurred to him, had remained in this condition. They were not loyal to a party or a country or an idea, they were loyal to one another."

Courtesy, The Children's Bureau, U. S. Dept. of Health, Education, and Welfare

LESSON 5

We Help

**We Help
Each Other**

help each
people together
other and

We work together in our family.

We want to help each other.

We want to help other people.

Do people help each other work?

You and I work together.

You and I help each other.

People help each other work.

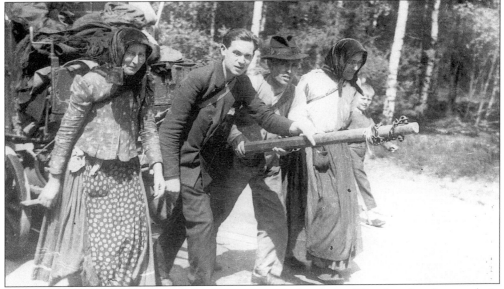

FRANZ TEBES. Without a hat, Tebes pulls a cart on the outskirts of Potsdam, heading south, in May of 1945. He was mistaken in the belief that they could all go back home. (Photograph courtesy of Martin Bajack.)

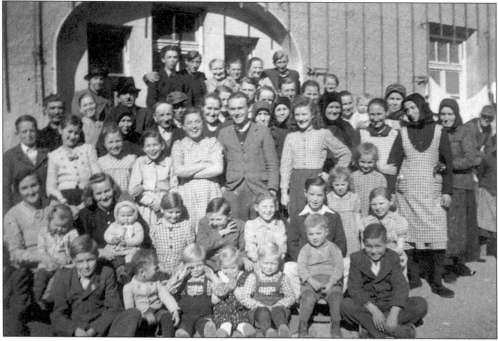

REICHERTSHOFEN LAGER, AUSTRIA, 1945. Pictured here is a group of refugees. (Photograph courtesy of Michael Stöckl.)

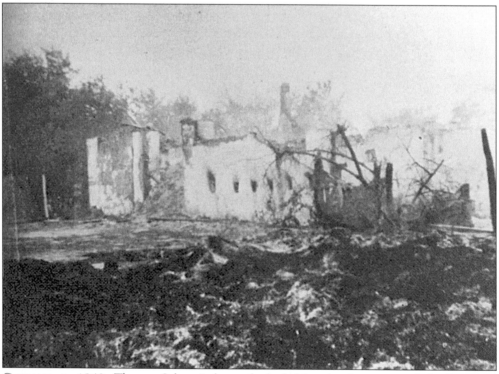

GORJANI, C. 1943. Thomas Scherer's house looked this way after an attack by Partisans. (Photograph courtesy of *Heimatbuch Tomaschanzi-Gorjani*.)

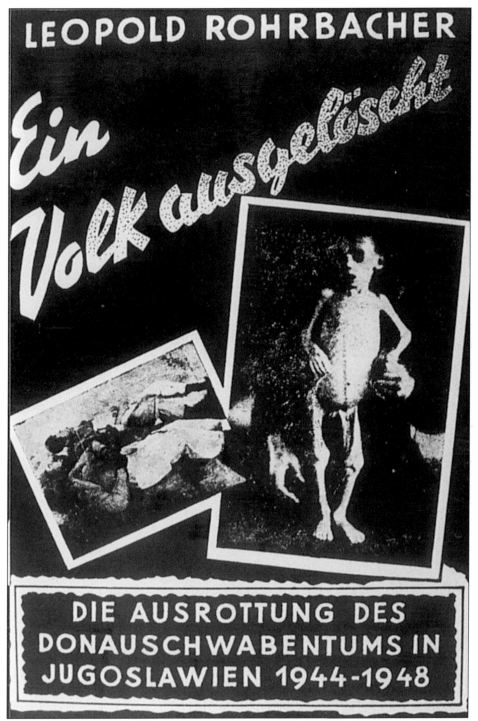

LEOPOLD ROHRBACHER. *A People Extinguished: The Extermination of the Danube Swabian Culture in Yugoslavia* is a book that is Rohrbacher's main historical effort, beyond his newspaper work, and is the story of his people during the Expulsion. This work still remains to be examined and translated into English. The child was brought in from a starvation camp in Yugoslavia.

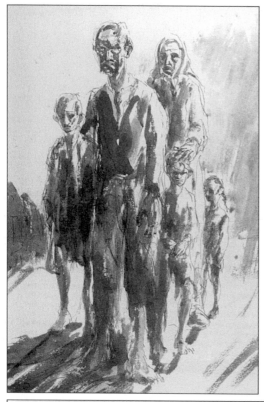

SEBASTION LEICHT, IM TODESLAGER.
"Die Hunger-und-Todeslager, die Titos Exekutivorgane 1945 für ihre vormaligen Mitbürger einrichteten, waren nichts anderes als mit Menschen vollgepferchte donauschwäbische Dörfer. In die Leidensgeschichte der Jugoslawiendeutschen sind eingegangen die Namen: Gakowo, Kruschiwl, Jarek, Rudolfsgnad, Molindorf, Syrmisch-Mitrowitza, Semlin und Kerndija."

The previous translates to the following: "The hunger and death camps, established by Tito's executive organs in 1945 for their previous fellow citizens, were nothing else than villages overfilled with Danube Swabians. In the story of suffering endured by the Yugoslavian Germans are engraved the names: Gakowo, Kruschiwl, Jarek, Rudolfsgnad, Molindorf, Syrmisch-Mitrowitza, Semlin and Kerndija."

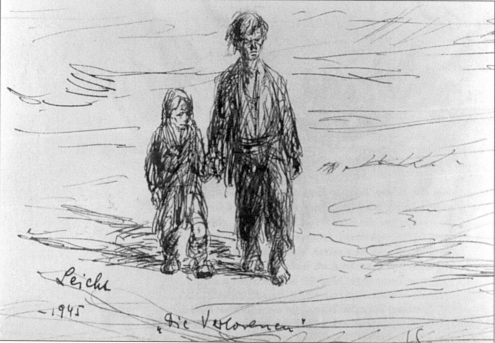

DIE VERLORENEN, 1945. These were the "Lost Ones" that the American Aid Societies wanted to save.

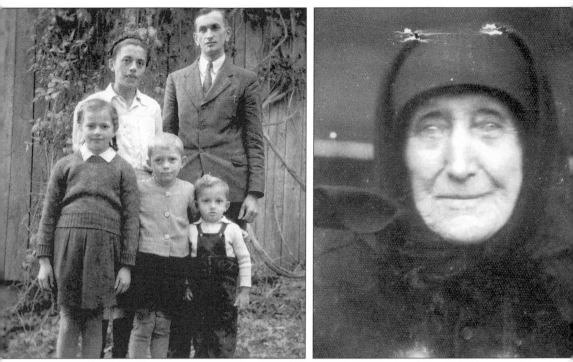

Left: **THE WELSCH FAMILY, AUSTRIA, 1947**. (Photograph courtesy of Horst & Annerose Görge.) *Right:* **MAGDALENA GLASENHARDT.** Seen above is Magdalena Glasenhardt's passport picture from 1944. (Photograph courtesy of Katherine Glasenhardt.)

GORJANI, 1941. These Danube Swabian children with Christmas toys were photographed in a courtyard in wartime Yugoslavia. (Photograph courtesy of Katherine Glasenhardt.)

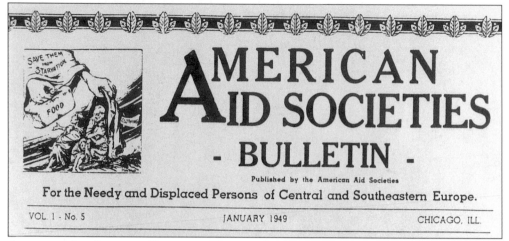

AMERICAN AID SOCIETIES
- BULLETIN -

Published by the American Aid Societies

For the Needy and Displaced Persons of Central and Southeastern Europe.

VOL. 1 - No. 5	JANUARY 1949	CHICAGO, ILL.

AMERICAN AID SOCIETIES BULLETIN. This was the periodical created by Nick Pesch and John Meiszner, which kept the American Danube Swabians informed of their legislative and humanitarian efforts.

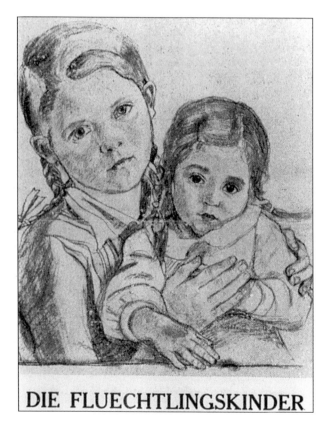

DIE FLUECHTLINGSKINDER

DIE FLÜCHTLINGSKINDER (THE REFUGEE CHILDREN), ARTIST UNKNOWN. This image appeared in the December 1948, American Aid Societies Bulletin.

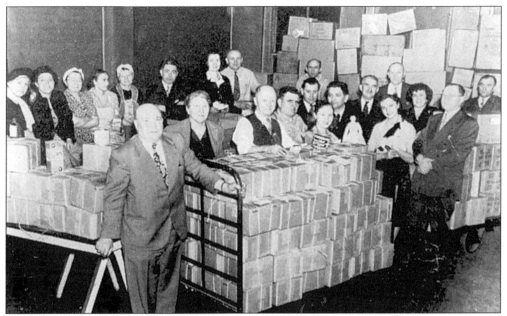

AMERICAN AID SOCIETY RELIEF. These supplies were collected in Chicago, in 1948, for shipment overseas. (Photograph courtesy of an American Aid Society pamphlet.)

DONAUSCHWÄBISCHEN HILFWERKS. This organization was founded by Peter Max Wagner (leaning on packages), who is seen here in 1946. This group alone managed to send over 26,000 packages of humanitarian aid to Germans in European refugee camps. (Photograph courtesy of the New York Donauschwaben.)

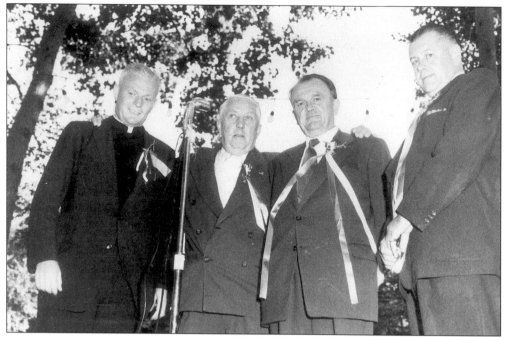

JOHN MEISZNER, LUDWIG LEBER, AND CHARLIE WEBER. These three pose with an unidentified priest at an American Aid Society fundraiser, c. 1957. (Photograph courtesy of the American Aid Society.)

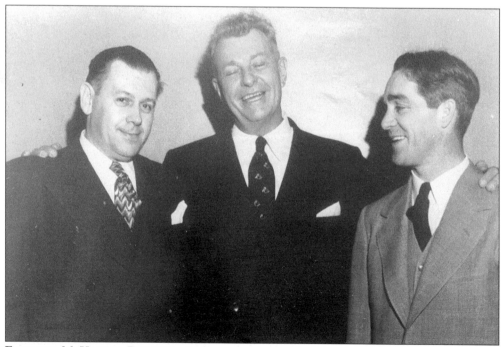

EVERETT MCKINLEY DIRKSEN. Dirksen appears with John Meiszner and Congressman Timothy Sheehan at the annual banquet of the American Aid Society at the Logan Square Masonic Temple in Chicago, December 10, 1950. (Photograph courtesy of Helen Meiszner.)

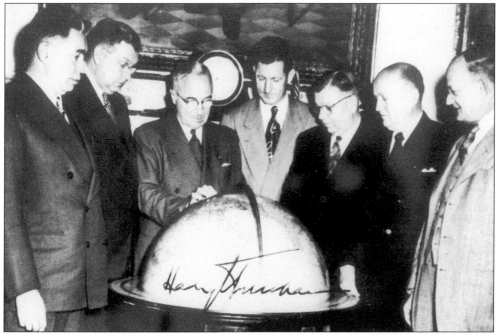

HARRY S. TRUMAN. The President of the United States meets the presidents of the American Aid Societies, *c.* 1952. Seen here, from left to right, are Nick Pesch, unidentified man, Harry S. Truman, John W. Gibson, Displaced Persons commissioner, unidentified man, Peter Max Wagner, and Mike Schmidt. (Photograph courtesy of the New York Donauschwaben.)

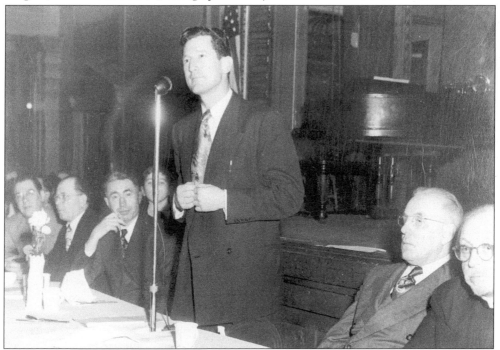

JOHN W. GIBSON. The DP commissioner speaks to the Donauschwaben in Chicago, *c.* 1950. (Photograph courtesy of the American Aid Society.)

onauschwäbische Herz
Welt schlägt für uns

Überblick über die landsmännischen Hilfsorganisationen in den USA

schließen ihre Ohren und Herzen. Sind wir aber stolz, daß die Masse mit uns fühlt und wir doch, trotz allem Elend, das Gefühl haben dürfen, nicht gänzlich verlassen in der Welt zu stehen. Die bitteren Enttäuschungen, die viele von uns in Österreich und Deutschland erlebt haben, werden überstrahlt von der warmen Anteilnahme unserer schlichten, aber treuen Landsleute in den Vereinigten Staaten, Kanada und Südamerika, die seit drei Jahren über den Ozean zu uns herüberströmt und neue Hoffnungslichter in hoffnungslosen Herzen entzündet.

Wir wollen kurz die hauptsächlichsten Organisationen, deren unermüdlicher Arbeit es zu verdanken ist...

Vereinigungen in Nordamerika ist die „AMERICAN AID SOCIETIES FOR THE NEEDY AND DISPLACED PERSONS OF CENTRAL AND SOUTH-EASTERN EUROPE" in Chikago. Ihr Vorsitzender ist der aus Krnje in der Bacska stammende Nick Pesch, Schriftführer John Meißner, ein Schwabe aus Ungarn. In dieser Organisation sind die landsmännischen Vereine der meisten Städte zusammengefaßt. Sie entfaltet eine rege Propagandatätigkeit in unserem Interesse und spornt die ihr angeschlossenen Vereine zur gesteigerten Sammeltätigkeit an. Viele Pakete und Kisten wurden durch sie, die auch in Österreich und Deutschland ihre Vertrauensleute hat, an Notleidende geschickt.

Nik Pesch, Präsident

Father Matthias Lani, Los Angeles

FATHER LANI AND NICK PESCH. The Danube Swabian heart all over the world beats for us, states an article from the *Neuland*, December 25, 1948.

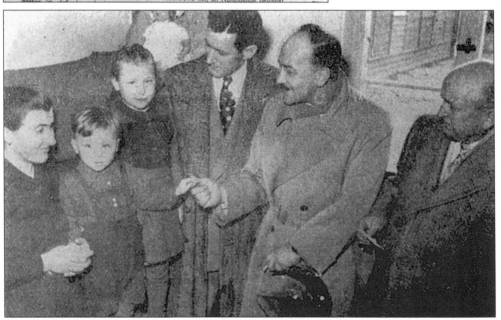

The *Neuland* of March 4, 1951, had a large article dealing with the visit of John W. Gibson and Peter Max Wagner to a camp in Salzburg, Austria. Here, John Tarczynski of the Displaced Persons Commission's Salzburg office promises to look into the case of a family who had been denied immigration because the father had served in the Romanian Army.

98

Deutsche Heimatlose in die USA

Präsident Mr. Gibson und Peter Wagner in Salzburg

Der Vertreter des „Neuland" hat noch in München mit dem Präsidenten der DP-Kommission in Washington, Mr. John Gibson, eine Unterredung gehabt und in einem ausführlichen Bericht über den Zweck seiner Studienreise in Europa berichtet. Wir konnten mit Genugtuung die Tatsache registrieren, daß der höchste Vertreter der amerikanischen Auswanderungsbehörde das Problem der volksdeutschen Auswanderung dank der wirksamen Aufklärungstätigkeit unseres Brooklyner Landsmannes Peter Wagner in seiner ganzen Kompliziertheit kennengelernt hat und — wie er mehrmals erklärte — auch bestrebt sein wird, eine zufriedenstellende Lösung zu finden. Nachfolgend berichten wir über seinen Aufenthalt in Salzburg.

Mr. John Tarczynski, der Leiter der DP-Kommission in Salzburg liest das „Neuland"

Infolge des Gesetzes „zur Bekämpfung staats-

verschiedenen Fälle schuldloser Menschen, die den harten Verbotsbestimmungen zum Opfer fielen, und die Mr. Gibson durch die Betroffenen selbst mitgeteilt wurden, haben auf ihn einen sichtlich tiefen Eindruck gemacht. Seine Liebe zu den Kindern, die ihm im Lager und beim Abschied eines Transportes von Auswanderern auf dem Bahnhofe ihre Händchen entgegenstreckten, und an die er Süßigkeiten verteilte, war geradezu rührend. Nachfolgend berichten wir über den Salzburger Aufenthalt Mr. Gibsons, wo er Gelegenheit hatte, auch mit dem Leiter der hiesigen DP-Kommission, Mr. John Tarczynski, ein uns außerordentlich wohlgesinnter und hilfsbereiter Herr, die Probleme zu besprechen.

Verhandlungen in Wien

Wie wir in unserer letzten Folge berichteten, flogen Mr. Gibson, der Leiter der DP-Kommission in Europa, Mr. Robert Corkery und Peter Wagner von München nach Wien, wo sie mit dem Leiter der IRO von Österreich, General Woods, und dem Ministerialdirektor im Innenministerium Dr. Just dem das Flüchtlingswesen in Österreich unterstellt ist, eingehende Unterredungen hatten. Mit Rücksicht darauf, daß Donnerstag, der 22. Februar, ein

wiederum haben Australien oder Kanada zum Ziel ihrer Auswanderung. Während seines zweistündigen Rundganges interessierte sich Mr. Gibson eingehend für die organisatorischen und sanitären Einrichtungen des Lagers, und ließ sich mit mehreren Lagerinsassen ins Gespräch.

Im volksdeutschen Umsiedlungslager

Aus dem Lager der Hellbrunner Kaserne begab sich Mr. Gibson mit seiner Begleitung in das volksdeutsche Umsiedlungslager, das sich bekanntlich auf dem Gelände des Hotel „Europe", hinter der Baracke des „Christlichen Hilfswerkes" befindet. In diesem Lager werden die volksdeutschen Auswanderer aus ganz Österreich gesammelt, hier warten sie die Erledigung der letzten Formalitäten ab und von hier aus treten sie dann über Bremerhaven die Reise über das „große Wasser" an.

Mr. Gibson wurde in dem Lager von dem Leiter des Umsiedlungsamtes der Landesregierung Salzburg und Vertretern der donauschwäbischen Landsmannschaft herzlichst begrüßt und durch das Lager geleitet. Er besichtigte die Wohnräume, die sanitären Einrichtungen, und unterhielt sich mit verschiedenen Lagerinsassen. Der Leiter

NEULAND, MARCH 4, 1951. DEUTSCHE HEIMATLOSE IN DER USA.

Präsident Mr. John Gibson im volksdeutschen Umsiedlungslager in Salzburg: In der Mitte des Bildes (ohne Hut): Mr. Gibson, links von ihm unser Landsmann Peter Wagner, rechts von Mr. Gibson der Leiter der DP-Kommission in Frankfurt, Mr. Robert Corkery, neben ihm der Leiter der DP-Kommission in Salzburg, Mr. John Tarczynski und Anton Rumpf, früherer Leiter des Christlichen Hilfswerkes. Der erste von links: Mr. Keith Turner, Leiter der Transportabteilung der IRO.

NEULAND, MARCH 4, 1951. THE AMERICANS IN AUSTRIA.

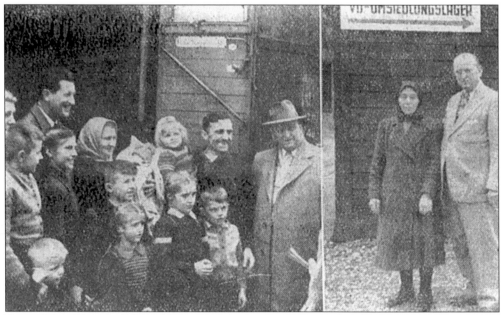

PETER MAX WAGNER. In Salzburg, Wagner sends off the Webel family (ten children) with John W. Gibson. In the next photo Wagner stands with a woman of Sekitsch, Yugoslavia, his hometown. She had apparently recently escaped Tito's grasp.

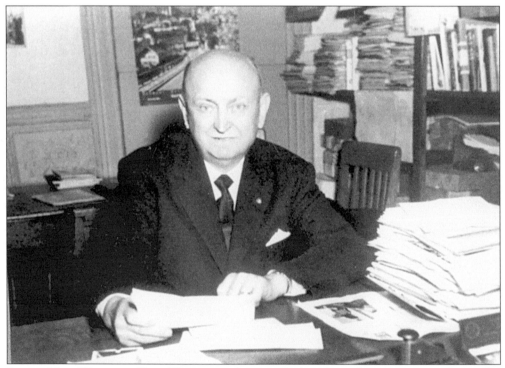

PETER MAX WAGNER. Here Wagner is photographed in his office in New York. On his desk are letters requesting the aid of his organization. (Photograph courtesy of the New York Donauschwaben.)

Eleven
WE PLAY

Thus far we have tried to demonstrate how well these people 'fit' into the American scene, as America itself defines that composition. This chapter continues that argument.

People Like To Play

LESSON 15

We Play

| there | most | park |
| some | come | shows |

Play is good for health.
There are many ways to play.
To have a good time is to play.
Every family needs to have a good time.
Children come to play in the park.
They like to come to the park.
The children need fresh air.
Some fathers and mothers come to play with the children.
There are other ways to have a good time.
Some people like to read.
They read to learn many things.
They have a good time at home.
Some people like to go to shows.
They have a good time at shows.

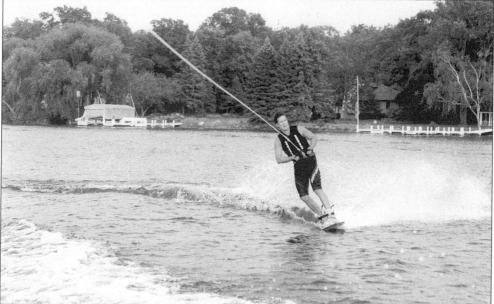

PETER TSCHURTZ. Peter plays on Lake Geneva, Wisconsin, near the house featured in Chapter Five. (Photograph courtesy of Susanna Tschurtz, 1998.)

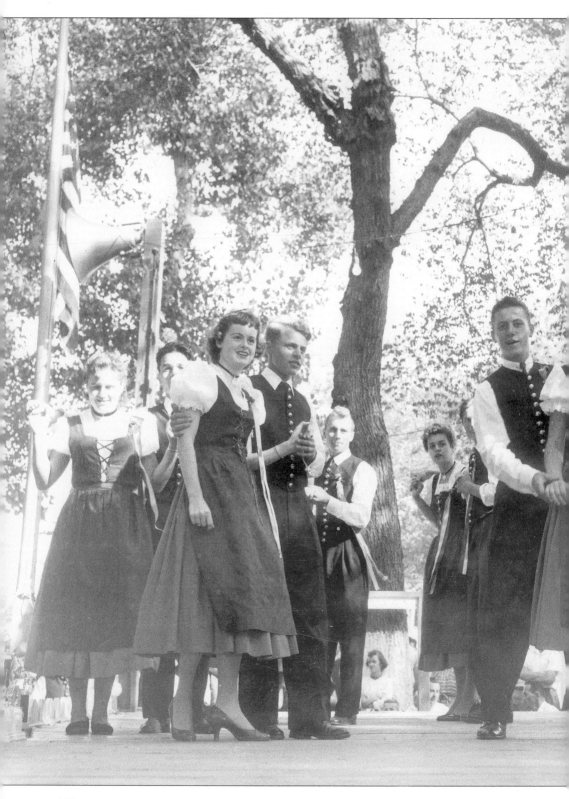

CHICAGO, AUGUST 4, 1957. The young adults stroll onto the stage for a dance in front of the crowd in Riverview Park. (Photograph courtesy of the American Aid Society.)

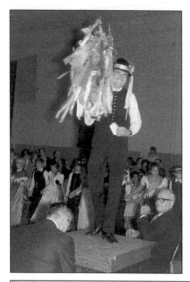

JOHANN KRIER. Krier auctions off the Strauss at the Kirchweih dance of 1972. If you buy one, whatever the price, the girl you love understands what she's worth to you. (Photograph courtesy of the Cincinnati Donauschwaben.)

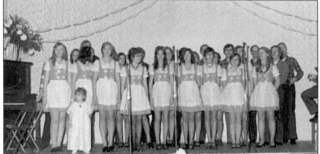

CHICAGO, 1974. Danube Swabian girls sing at the party in John Meiszner's honor. (Photograph courtesy of the American Aid Society.)

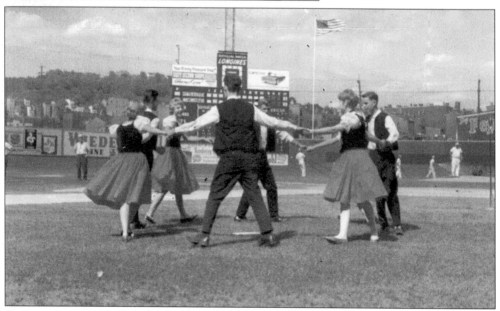

CINCINNATI, 1962. Danube Swabian kids danced for the Reds in historic Crosley Field. (Photograph courtesy of the Cincinnati Donauschwaben.)

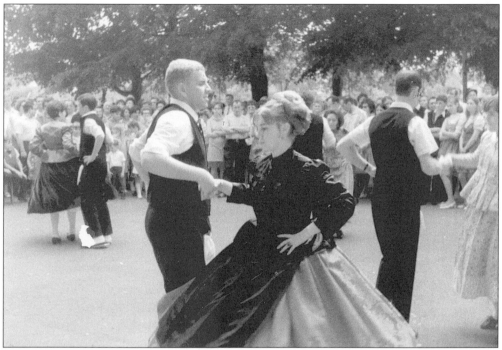

NEW YORK CITY, 1969. This dance group is performing at the Steuben Parade. (Photograph courtesy of Teschner, New York Donauschwaben.)

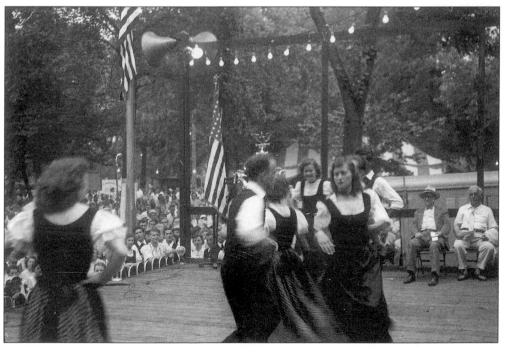

RIVERVIEW PARK, CHICAGO, C. 1956. This dance group entertains the crowd at a Memorial Day celebration. (Photograph courtesy of Joe Stein.)

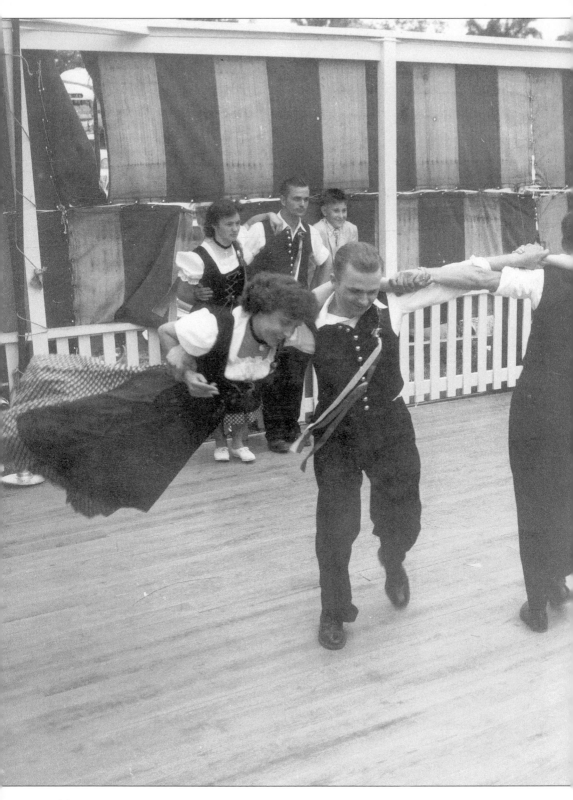

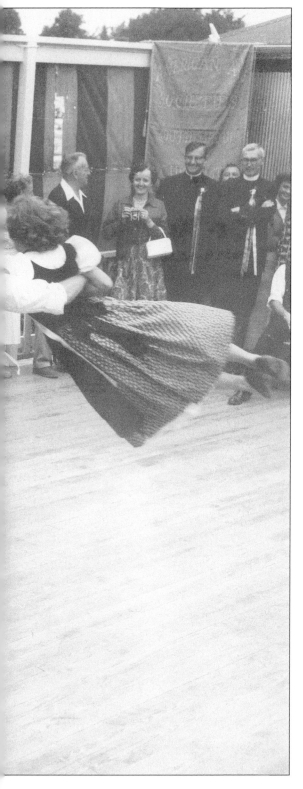

AMERICAN AID SOCIETY, LAKE VILLA, ILLINOIS, C. 1956. (Photograph courtesy of the American Aid Society; used by permission of Lewis Bunker Rohrbach of Picton Press, Rockport, Maine.)

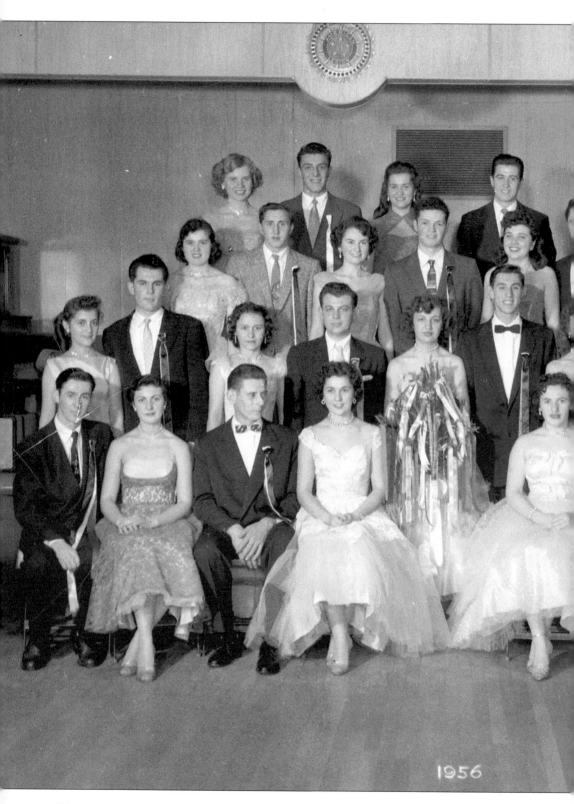

1956

CHICAGO, 1956. Joe Stein (second row, fourth from right) is seen here at the St. Huberter Kirchweih in the American Legion Hall. (Photograph courtesy of Joe Stein.)

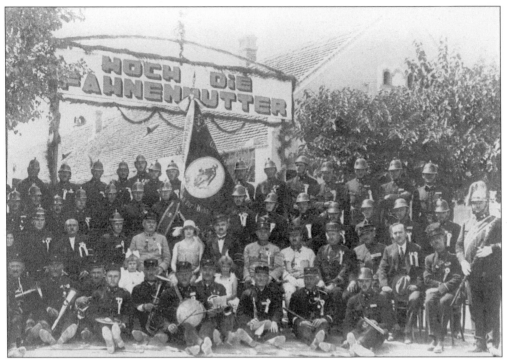

KERNEI, C. 1928. This celebration involved the blessing of the Firefighters Flag. Pictured here is the Volunteer Firefighters Marching Band. (Photograph courtesy of Adam Ackermann, *Kernei in der Batschka.*)

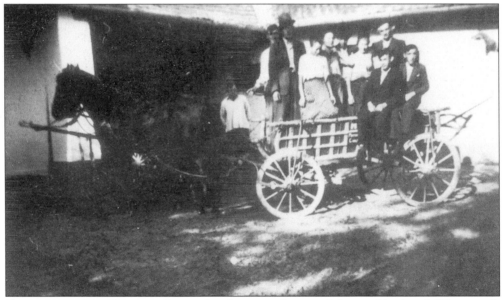

GORJANI, C. 1940. These people socialize during a ride around the neighborhood. (Photograph courtesy of Katherine Glasenhardt.)

110

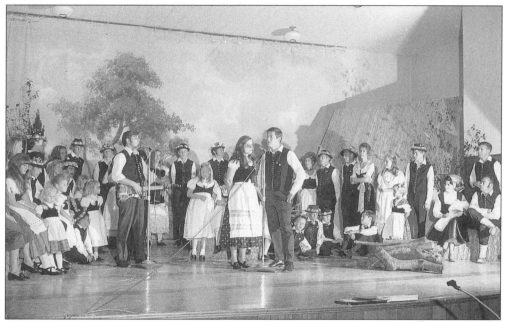

LOS ANGELES, C. 1970. The *Schwabenzug* tells the story of migrations. (Photograph courtesy of the Los Angeles Donauschwaben.)

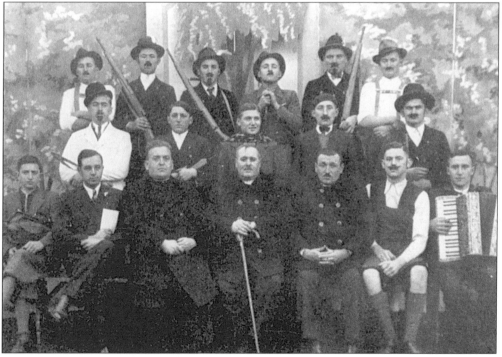

KERNEI, C. 1927. Seen here is a *Laienspielgruppe des Bauernjünglingsvereins* or a drama group. (Photograph courtesy of Adam Ackermann, *Kernei in der Batschka*.)

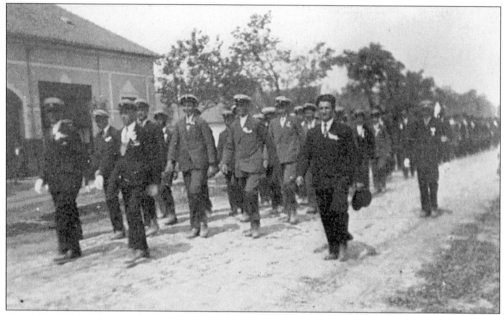

KERNEI, 1934. Shown above is the parade of the Young Men's Association. (Photograph courtesy of *Kernei in der Batschka*.)

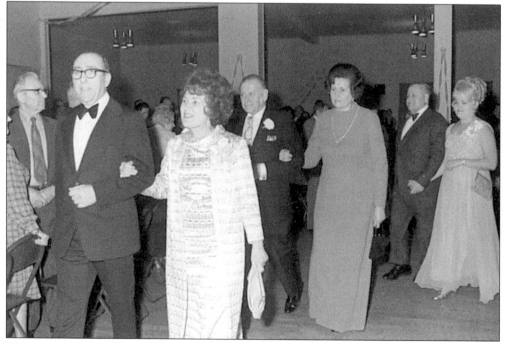

CHICAGO, 1974. Helen, John, and Joyce Meiszner are pictured at the banquet held in John Meiszner's honor by the American Aid Society. (Photograph courtesy of the American Aid Society.)

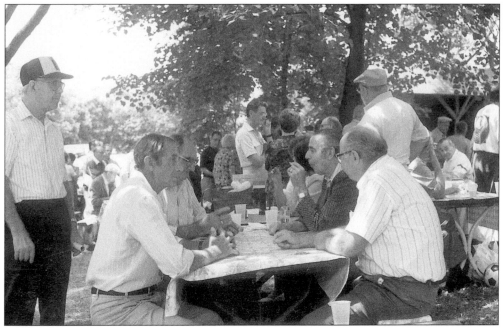

AMERICAN AID SOCIETY, 1998. These people are waiting for the deal; card-playing is a favored pastime. (Photograph courtesy of Raymond Lohne.)

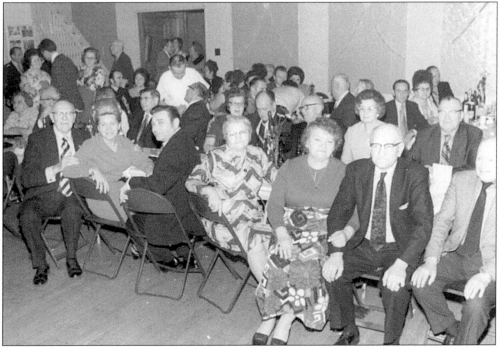

CHICAGO, FEBRUARY 2, 1974. One can notice a certain amount of relaxed sociability at the banquet for John Meiszner. Germans call this Gemutlichkeit. (Photograph courtesy of the American Aid Society.)

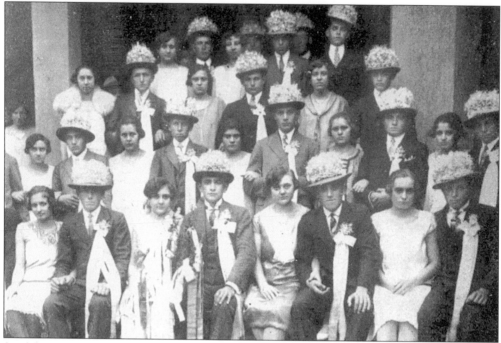

ST. HUBERT, C. 1927. A *Kirchweih* is pictured in this little town in the Banat. (Photograph courtesy of *Heimatbuch der drei Schwestergemeinden.*)

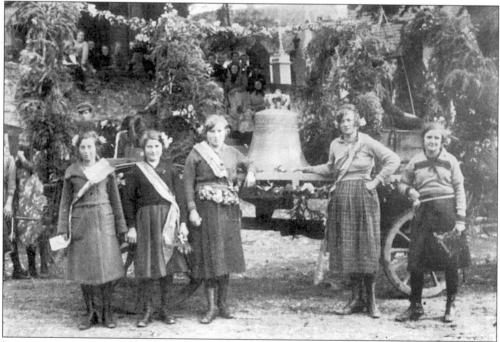

LOTHRINGEN, 1923. This celebration involved the blessing of the church bell in Hilbesheim. These girls are the winners of some special honor associated with this *Glockenweih*. (Photograph courtesy of *Heimatbuch der drei Schwestergemeinden.*)

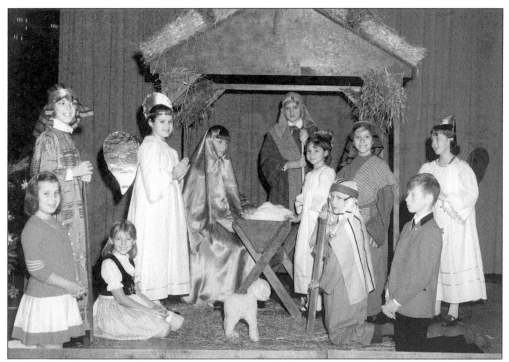

CLEVELAND, C. 1970. This picture shows a *Krippenspiel* or nativity story. (Photograph courtesy of the Cleveland Donauschwaben.)

DEBI AND ED TULLIUS. This pair is performing a traditional *Schuhplatt* dance at the 1994 Cincinnati Donauschwaben Oktoberfest. (Photograph courtesy of the C̶ Donauschwaben.)

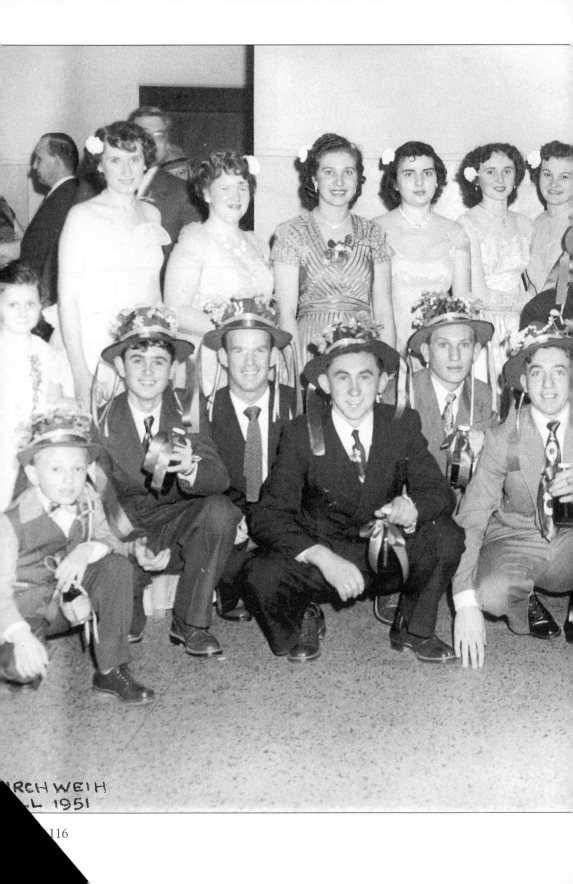

RCH WEIH
L 1951

116

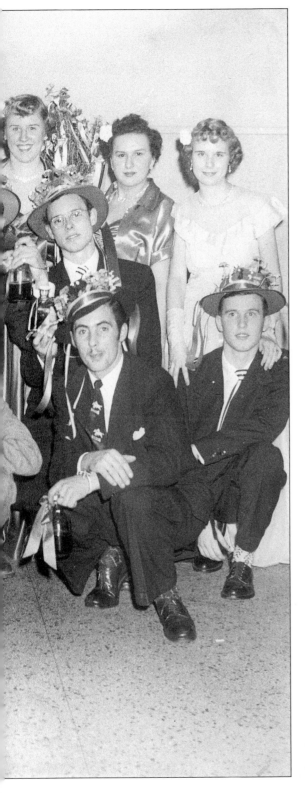

St. Louis, Missouri, 1951. *Kirchweih.*
(Photograph courtesy of the Mike
Wendl, St. Louis Donauschwaben.)

LOS ANGELES, 1974. A very little dance group is pictured with dance instructor Regina Greger. (Photograph courtesy of the Los Angeles Donauschwaben.)

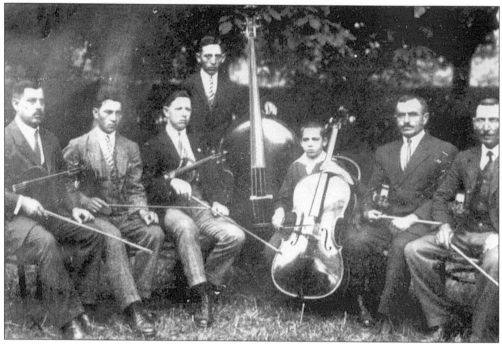

ST. HUBERT, C. 1927. Pictured here is the string orchestra of the town. (Photograph courtesy of *Heimatbuch der drei Schwestergemeinden*.)

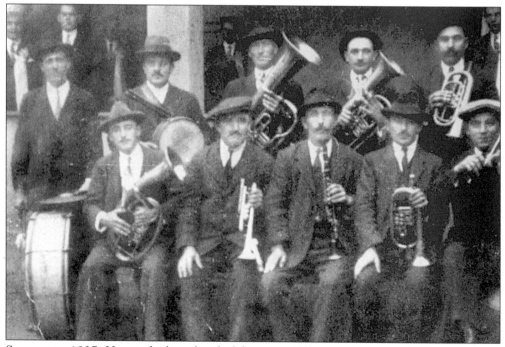

SOLTUR, C. 1927. Here is the brass band of the town. (Photograph courtesy of *Heimatbuch der drei Schwestergemeinden*.)

120

Twelve
WE REMEMBER

NICK PESCH MEMORIAL, 1999. This was not one of the lessons in the little Home Study Course booklet, but it should have been. (Photograph courtesy of Raymond Lohne.)

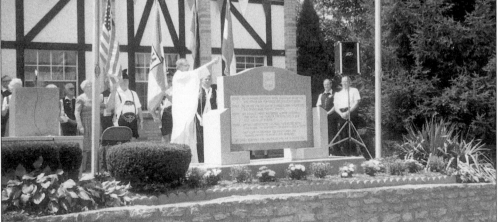

CINCINNATI, AUGUST 1998. Portrayed is the unveiling and blessing of the memorial to the Donauschwaben who perished in the Second World War. (Photograph courtesy of the Cincinnati Donauschwaben.)

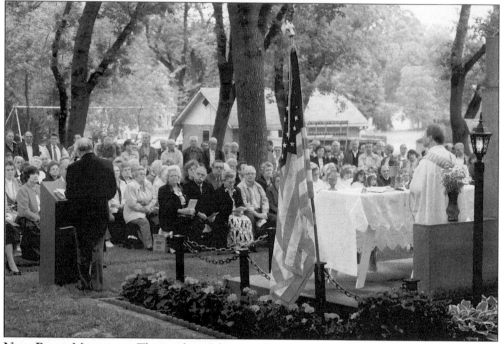

NICK PESCH MEMORIAL. This is where I first saw the painted wooden crosses with those names on them. (Photograph courtesy of Raymond Lohne, 1997.)

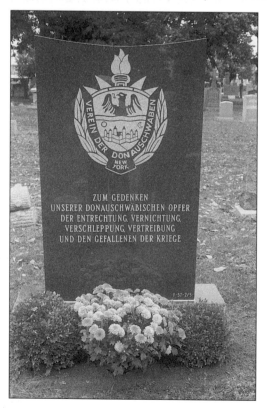

NEW YORK MEMORIAL. This memorial was erected by the Donauschwäbischen Hilfs- und Jugendverein. (Photograph courtesy of the New York Donauschwaben 1996.)

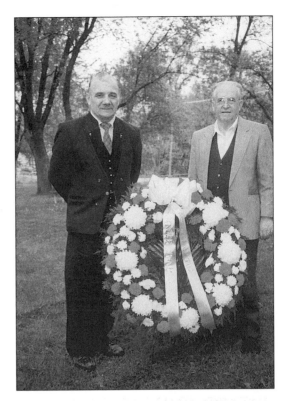

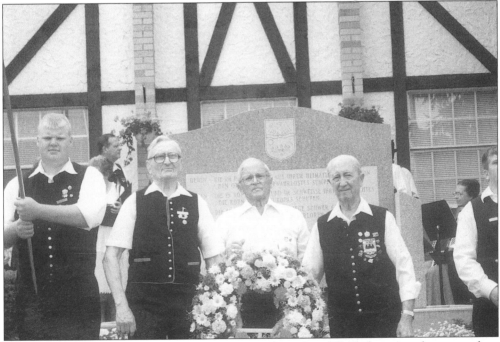

GEORGE FINGERHUT, PETER GUSTER, AND MIKE KONRAD. These three men lay a wreath at
the Danube Swabian Memorial during Cincinnati's 43rd Annual Donauschwaben Day, August
1998. (Photograph courtesy of the Cinti, Cincinnati Donauschwaben.)

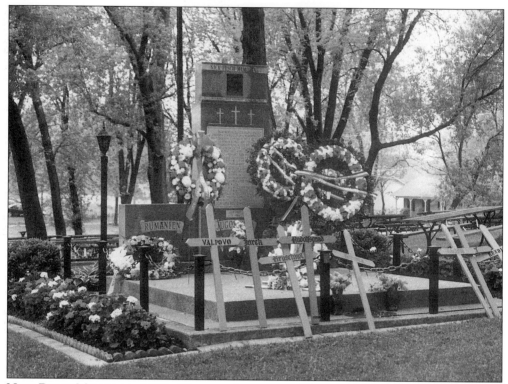

NICK PESCH MEMORIAL, 1997. (Photograph courtesy of Raymond Lohne.)

MEGAN LANDAUER. The great-granddaughter of Nick Pesch, on Memorial Day, 1999, visits the memorial for her first time, and this is my tribute to him. (Photograph courtesy of Raymond Lohne.)

124

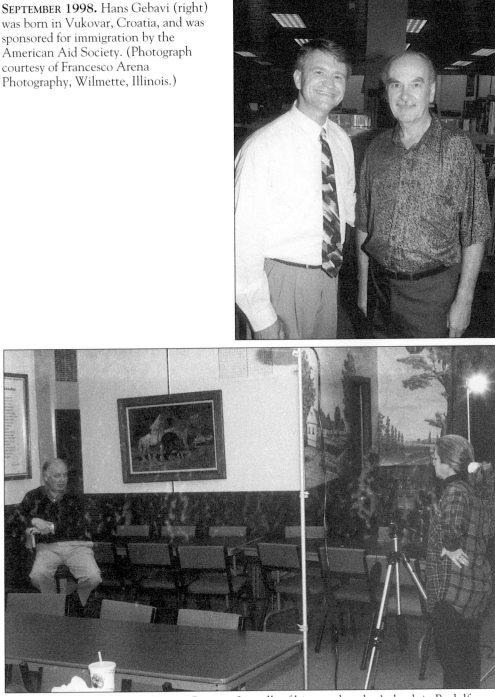

RAYMOND LOHNE AND HANS GEBAVI, BORDER'S BOOKS, DEERFIELD, ILLINOIS, SEPTEMBER 1998. Hans Gebavi (right) was born in Vukovar, Croatia, and was sponsored for immigration by the American Aid Society. (Photograph courtesy of Francesco Arena Photography, Wilmette, Illinois.)

JOSEPH STEIN AND LAURA MILLER LOHNE. Joe tells of his grandmother's death in Rudolfsgnad while this researcher's wife runs the video at the American Aid Society clubhouse, Chicago, 1996. (Photograph courtesy of Raymond Lohne.)

Aldous Huxley once wrote of building a Pantheon for professors in a gutted city of Europe, upon which he would inscribe in letters six or seven feet high, "SACRED TO THE MEMORY OF THE WORLD'S EDUCATORS. SI MONUMENTUM REQUIRIS CIRCUMSPICE." This seems an awfully harsh image for Huxley to conjure up against the teaching profession, but there it sits, an accusation in architecture. But is it a structure that will stand? I doubt it, for if it can be held that intellectuals were to blame, don't they also deserve credit? And who shall we start with? I suppose he must start with the professors at the Vienna Academy of Fine Arts, as I'm sure someone has suggested, for it was they who decided that Hitler's talents lay in architecture, not painting. Who could've guessed how right they would be? But if there ever is a Pantheon to Professors, this grateful student has some candidates of his own to suggest.

MELVIN G. HOLLI, PROFESSOR OF HISTORY, UNIVERSITY OF ILLINOIS AT CHICAGO. (Photograph courtesy of Melvin Holli.)

LEO SCHELBERT, PROFESSOR OF HISTORY, UNIVERSITY OF ILLINOIS AT CHICAGO. Schelbert was a recipient of the Ellis Island Medal of Honor. (Photograph courtesy of Raymond Lohne, 1996.)

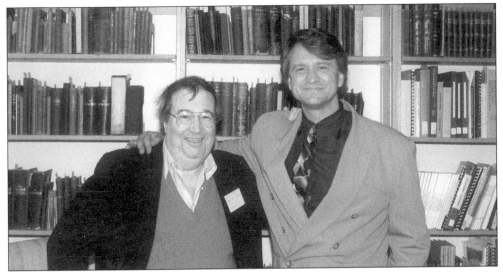

CHARLES M. BARBER. PROFESSOR OF HISTORY, NORTHEASTERN ILLINOIS UNIVERSITY, CHICAGO. Barber and Raymond Lohne attended the Max Kade Institute for German-American Studies, University of Wisconsin-Madison for a conference of the Society for German American Studies on April 18–21, 1996. Dr. Barber guided the author to the Donauschwaben as his M.A. advisor. (Photograph courtesy of Dr. Henry Geitz.)

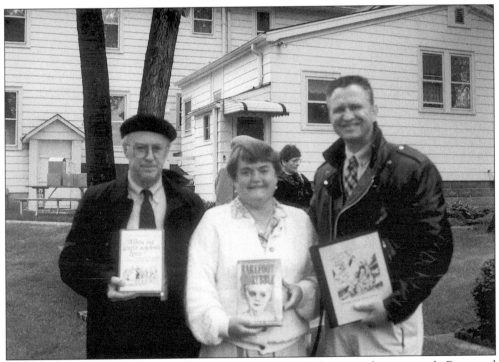

LEO SCHELBERT AND ELSA WALTERS. Schelbert and Walters can be seen with Raymond Lohne at the American Aid Society picnic grounds, 1998. (Photograph courtesy of the *Eintracht German Weekly*, Chicago, Illinois.)

Select Bibliography

Jacob Steigerwald. *Donauschwavische Gedankenskizzen aus USA*, self-published, 1983.

Adam Ackermann. *Kernei: Ein Deutsches Dorf in der Batschka 1765–1945*, self-published, 1978.

Josef Werni, Konrad Reiber, Josef Eder. *Heimatbuch Tomaschanzi-Gorjani*, self-published, 1978.

Nikolaus Hess. *Heimatbuch der drei Schwestergemeinden, St. Hubert, Charleville, Soltur im Banat 1770–1927*, self-published 1927, re-published 1981 (Munich) with Michael Gross.

Anton Tafferner. *Heimatbuch Batschsentiwan*, self-published, 1980.

Sebastion Leicht. *Weg der Donauschwaben. Dreihundert Jahre Kolonistenschicksal. Ein Graphischer Zyklus.* Passau: Verlag Passavia Passau, 1983.

Susanna Tschurtz. *Heimatbuch Batschsentiwan*, self-published, 1980.

Michael Stöckl. *The Kerneir Families Gartner and Wurtz and Their American Branches.* Chicago: self-published, 1974.

Alfred-Maurice de Zayas. *A Terrible Revenge, The Ethnic Cleansing of the East European Germans, 1944–1950.* (New York: St. Martin's Press, 1994) p. xvii.

Charles M. Barber. "A Diamond in the Rough, William Langer Reexamined," *North Dakota History, Journal of the Northern Plains,* Vol. 65, No. 4 (Fall 1998).

Aldous Huxley. Brave New World, (New York, Harper & Row, 1969), p. viii.

George Orwell, 1984, (New York, Harcourt, Brace & Jovanovich, 1949).

Raymond Lohne. *The Great Chicago Refugee Rescue,* (Rockport, Maine: Picton Press, 1997).

Melvin G. Holli. *The American Mayor, The Best and the Worst Big-City Leaders.* (Penn State University Press, 1999).

Leo Schelbert. "On Becoming An Emigrant: A Structural View of Eighteenth- and Nineteenth-Century Swiss Data," in *Perspectives In American History* Vol. VII, 1973, p. 461.

Richard S. Levy. *Antisemitism in the Modern World. An Anthology of Texts.* Houghton Mifflin, 1990.

James Cracraft. *The Petrine Revolution in Russian Imagery.* (Chicago, University of Chicago Press, 1997) p. 17.

Michael Perman. *Perspectives on the American Past.* (Lexington, Mass., D.C. Heath & Co., 1996) p. xx.

The author wishes to personally thank Mary Kay Vaughn, Director of Graduate Studies, UIC; Lynn Hattendorf Westney, Associate Professor, Assistant Reference Librarian, UIC; Jennifer Edwards, Assistant to the Chair, UIC; Linda Van Puyenbroeck, Assistant to the Director of Graduate Studies; UIC, and Rahman Ali, UIC History Department; Jennifer L. Wagner, Border's Books & Music; Mohan K. Sood, Dean of the Graduate College of NEIU; and Klaus & Walter Jungling, publishers of the *Eintracht* German weekly newspaper.

This book is for Sarah Arena, my *bella bambina*, Jason Garcia, Welton Wright, Diomina Giralamo, and the new *bella bambina*, Natalia Raelynn Wright, William Wallace McGillivray, Tommy Anderson, my beloved children all, and little Laura, my beloved wife, and for the *Schwobs*.